KECK, COWPATS AND C

Keck, Cowpats and Conkers

Frances Mann

BREWIN BOOKS

First published by
Brewin Books, Studley, Warwickshire, B80 7LG
in September 1995

ISBN 1 85858 060 9

British Library Cataloguing in Publication Data
A Catalogue record for this book is available from the British Library

Typeset in Plantin by Avon Dataset Ltd, Bidford on Avon, Warks, B50 4JH
Printed and bound at The Alden Press, Osney Mead, Oxford

Dedicated to the younger members of my family, Christopher, Philippa, Louise, Adrian, Stephanie, Kate, Alexandra and Andrea, that they may never forget their heritage.

ACKNOWLEDGEMENTS

My Family for their help, encouragement and patience, especially the 'Harbury Connection' for their unstinted generosity, long-stay accommodation and sustenance (thank you Pat).

My Brother, David, and his incredible memory, compared to my own (but then, he has youth on his side).

My Sister, Gillian, for her special contribution and illustration.

Gillian Gurden, not only for the practicalities of transport so willingly given, but also for our much valued long-time friendship.

Julie Killian for her professional help and advice.

Joan Clarke, Celia Barratt, Jessie Rolfe and Gill Carter and last, but not least, a heartfelt thank you to both those 'old' and 'new' residents of Harbury, far too many to mention individually, for the loan of documents and photographs and their hospitality, leaving me with a warm feeling of 'belonging'.

Warwickshire County Council, Department of Libraries and Heritage, for permission to reproduce old postcards.

Bibliography

Hungry Harbury
A Guide to a Warwickshire Village

Linda Ridgley

The Warneford Hospital
A Hospital's Story

Graig D. Stephenson

Second World War

Martin Gilbert

Children of the Blitz

Robert Westnall

Windmills of Warwickshire

Wilfred A Seaby)
Arthur C Smith)

Hidden Warwickshire

Betty Smith

Evergreen Magazine

Cheltenham

Contents

Introduction

HARBURY, a small village in Warwickshire, is thought to have been established by Hereburg, an Iron Age noblewoman and her tribe somewhere between 600 and 300 BC. Evidence has also been found, in the form of Bronze Age cooking pits carbon dated at 1400 BC, of earlier human habitation. Following the Ice Age, thick forest covered most of the land. The ridges on the higher ground being drier and less dense became the natural early highways of prehistoric man as he travelled from place to place.

Some of these ancient roads are still in use today. One of the earliest examples was the old Lear Street which ran from Wappenbury through Ufton, following a line along the present day Church terrace and Ivy Lane. It then continued South into Beggars Lane, bearing left along Plough Lane into Bishops Itchington (this was for centuries the main route from Warwick to Banbury and London).

No evidence of Roman occupation had been found in Harbury, although a military garrison is known to have existed in the neighbouring village of Chesterton. Chesterton is situated to the West of Harbury, lying directly alongside the Roman Fosse Way. Many Roman artifacts have been discovered in and around Chesterton, also the site of a Roman Villa.

The Saxons cleared the forest and cultivated the land introducing the 'three field' system. There are still remnants of ridge and furrow ploughing to be seen in the field to the right of lower Mill Street behind the Medical Centre. The three farms standing on the ancient sites today bear the names Westfield Farm, Northfield Farm and Eastfield Farm. According to the Doomsday Book – 1086 – Harbury then covered about 2500 acres and was valued at two shillings.

Nothing of historical interest seems to have happened in the village, possibly because it occupied rather an isolated position situated high on a hill, skirted by the main highways. This must have been a great advantage when marauding tribes were in the area and during the time of the Black death for instance when most of the population of Chesterton and Bishops Itchington were wiped out.

The village, known as Hungry Harbury, was never a rich village. The soil was poor, however there was a good supply of spring water and wells abounded throughout the village.

Farm work was the main industry until the 19th Century when limestone quarrying and work on the Oxford to Birmingham branch of the Great Western Railway created an alternative source of employment.

Chapter One

EARLY ONE MORNING

It was still dark as I set off on that early morning drive from Sussex to Warwickshire. I had decided to pay a surprise visit to my parents who lived in the village of Harbury. The village where I was born and where my family had dwelt since the 1880s when my great grandfather, John Mann, a butcher by trade, had moved from the neighbouring village of Chesterton, the home of my forebears who had farmed in that once prosperous area for generations.

I hoped to make good progress before the build up of traffic began. I drove contentedly along the quiet country roads savouring the peace and quiet. My thoughts were centred on the prospect of a few relaxing days at home away from the pressures of a demanding job and the pleasure that I knew my unexpected arrival would give to my father, who had not been in the best of health for some time.

Dawn was just breaking as I wound down the windows of my car, breathing in that unique morning smell that is peculiar only to the English countryside.

The birds were singing their age old chorus of welcome, ushering in what promised to be another fine day. It seemed like sacrilege to use the motorway, stretching snake like mile after monotonous mile on such a wonderful morning. On an impulse I decided to change direction and take the round about route and so enjoy the leafy lanes and pretty villages of the southern counties as I made my way northwards. Suddenly, in the glare of my headlights, I saw reflected for one brief moment the startled amber eyes of a fox. Swiftly he crossed the road in front of me, quickly disappearing through the hedgerow on the opposite side. No doubt, now replete, making his way homeward to sleep and dream of his nocturnal adventures.

I pulled off the road into a narrow lane and there sat on a farm gate to watch the magic of the sunrise painting the sky with those first brush strokes of colour. That deep orange glow studded with gold and silver rays of light shimmering through a backdrop of trees, their branches stretching like fingers, ever upwards as if paying homage to the miracle of the birth of a new day, a sight which never fails to fill me with awe and wonder.

As it became lighter I fetched my flask of coffee, sandwiches and an old blanket from the car. Climbing the gate I settled down on grass still covered with those tiny shimmering stars of dew.

I sat enjoying my solitary meal, and soon became aware that I was being carefully observed by a family of rabbits. After making several timid approaches they finally decided that I was quite harmless, and proceeded to join me at breakfast, daintily nibbling away at the lush green grass and plants that grew all around in abundance.

A faint humming sound came across the fields from the distant motorway disturbing the still morning air. I felt glad that I was not taking part in that race against time with those lemming like creatures sitting bolt upright in their driving seats, feet pressed hard down on their accelerators, staring straight ahead with glazed zombie like attention, driving as if their very lives depended on getting from A to B in the shortest possible time. Who would choose to inhale that putrid mixture of petrol and diesel fumes I pondered as I sat on my sweet smelling, multi-coloured carpet of daisies, buttercups, vetches and dainty grasses nodding gracefully in the breeze.

I wondered if my ancestors would have experienced this feeling of utter contentment as they worked on the land and tended their stock.

Looking around that peaceful meadow, it was as if time stood still and that nothing had changed for a thousand years or more. Indeed this has been confirmed in some counties by research on ancient hedgerows.

On the distant Downs I could now make out the figures of tiny cows and sheep looking for all the world like the carved wooden farm animals that my brother and I played with as children. In this euphoric mood I continued on my journey, making my way through the narrow lanes bordered with clouds of creamy Cow Parsley, known in Warwickshire as Keck and in Sussex as Queen Anne's Lace.

Suddenly, some miles ahead, the traffic began to slow down, first to a crawl, then finally ground to a complete halt.

I left my car to investigate the cause of the hold-up and gazed with a sinking heart at the scene before me.

Too late I remembered reading of work in progress on the extension of the motorway that I had sought to avoid. My favourite route home was slowly being eroded. There on the horizon, resembling gigantic prehistoric monsters, necks dipping, heads rising, their mechanical jaws snatching up great clods of earth and flora which they spat out into the waiting lorries to be carted away, were the huge earth moving machines, chewing up everything before them, leaving a gaping sore on the earth's surface. As I stood witnessing the carnage, I thought it ironic that only an hour or so before I had been lying in that delightful field of wild flowers in my own cloud cuckoo land.

How wrong I was to imagine that things were as they had always been. What untold destruction were these savage thrusting giants inflicting beneath the ground? Crushing delicate wild flowers, some unique to the area,

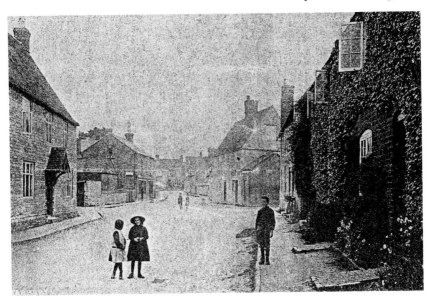

Reproduced from Postcard, Warwick Records Office

*Upper Mill Street, Harbury. On the right, old 17th century cottages
on a site of the present supermarket and flats.*

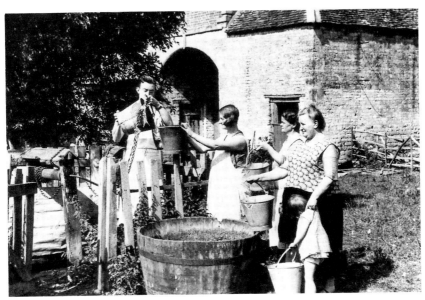

*Sid Cowley, Mrs Gladys Austin, Mrs Turner, Mrs Biddle, Barbara Biddle,
drawing water from the well. The old Dovehouse stands in the background.*

such as I had been admiring a short time before. Sweeping away the natural habitat of birds, insects and animals. Indeed, the creatures themselves would have no defence against such savagery. What else was being swept away in their path? Treasures such as the wonderful fossilised ferns and flowers that had taken millions of years to evolve. Possible evidence of our past history. The homes and graves of ancient man and creatures that had lain undisturbed for centuries lost for ever by man's thirst for progress.

I thought of that wonderful Roman villa at Fishbourne in Sussex, discovered only after work on a similar project had completely destroyed a large part of it.

Then I thought of Harbury, my own village, and the enormous changes that had taken place since the Second World War.

I thought of the meadows and fields where we had played as children.

I thought of Alcock's field, near the church, where as a small girl I can remember being lifted up onto the wooden stile to watch the lambs playing under the watchful eye of the mother sheep as they danced and played around the ancient dovecote, alas now demolished, believed by some to be the only remaining evidence of a once splendid manor house that stood on the site in Dove House Lane.

I thought of the field down Park Lane where I had once proudly won a prize at a village fete dressed as a mini shepherdess, complete with tiny crook and woolly lamb.

I thought of the beautiful Manor House orchards where on one day a year we village children were allowed to pick huge armfuls of golden daffodils, donating whatever small sum we could afford to Mrs Joan Farley's favourite charity, the RSPCA.

I thought of the flower strewn field next to my grandmother's house in Mill Street where a photograph, which I still have, was taken of me at about a year old, standing in a sea of daisies and buttercups.

I thought of the field along Butt Lane where I remember standing with my mother watching my father through the gate, along with other village men tossing huge pitchforks full of golden hay, and waiting patiently for the men's break time when we would join Dad sitting on the grass in the shade of enormous trees sharing a cool drink of home-made lemonade (beer for Dad) and a feast of bread and cheese and cold bread pudding which our Mother had brought tucked in the end of my brother's pram.

All now vanished beneath layers of tarmac and rows of look-alike brick boxes.

I thought of those charming old cottages. Whole rows demolished by the greedy money-motivated developers to make way for eyesores such as ugly supermarkets which were, and still are, totally unnecessary in a village. All now gone forever.

As I stood completely immersed in thoughts of the past, it came to me how lucky we were, my generation, to have experienced the freedom and joy of country children growing up in a village where life had changed very little for decades. In those pre-TV and video days we enjoyed the simple pleasures and were, I am sure, far more content and appreciative of small luxuries. Or is it true that as we become older and memory becomes blurred, we only remember the good things, our minds rejecting the bad?

At that moment, I resolved to record those sweet childhood memories, for how else would my children and my children's children learn of their heritage?

Since that day, my daughters and myself have left that green and pleasant land to settle twelve thousand miles away on the other side of the world.

I suppose like all true expatriates, since leaving I have become even more aware of our proud heritage. Perhaps, because of this, it has become more important than ever for me to carry out that promise made on a bright summer's morning so long ago.

The promise to record these recollections of my early life, the village and its people, my family, my roots.

Chapter Two
FIRST RECOLLECTIONS

According to my mother, my entry into the world was not without a struggle. Weighing a little under four pounds I finally arrived at 3.40 am on March 11th, 1931, and was immediately christened and named Frances Vera Mary.

I was born at the Warneford Hospital, Leamington Spa. Alas, even as I write, the death knell sounds and the developers wait in the wings to pick over the bones of that fine old institution which has served the town and its surrounding areas so well since 1832.

In 1931 the maternity cases were accommodated in 'The Herbert Beaumont Cottage Hospital', then known as 'The Cottage'. This was built in 1884 under the patronage of the Reverend J.A. Beaumont, and was a separate structure situated at the rear of the main building. In 1939 a purpose-built Maternity Unit was built and named 'Cay Block' in recognition of devoted service to the Warneford Hospital by Mrs Annie Cay, the wife of a local glass manufacturer who, with her husband's support, had launched the project with a donation of £1,000. 'The Cottage' then became the Matron's house, and in latter years was converted into part of the administration area.

When, at a few weeks old, I was pronounced strong enough to leave hospital, my mother took me home to No. 3 Church Street, Harbury, where I was to spend the first five years of my life. By all accounts I was a puny, ugly looking specimen, so much so that when my mother proudly presented my grandfather, Edmund Mann (known locally as 'Ned') with his first grandchild he took one look, snorted in disgust and remarked "yorl never rear 'er". My mother never forgave him for that slur on her firstborn and would often relate this tale with great relish as I eventually grew into a normal, healthy child.

No. 3 was a small terraced cottage. One in a row of six with no bathroom or mains water. This was winched up from a well in the communal back yard, although I can clearly remember our mother fetching water in a pail from the parish pump which I am pleased to see is still situated around the corner in Crown Street. No doubt this was when, for some reason or another, the village water levels fell (possibly in the dry summer weather).

Along with the other five cottages, we also shared the wash-house. This building ran alongside the wall backing onto 'The Dog Inn'. Inside was a

huge brick built copper. A long wooden bench ran along one wall to support the tin baths used for washing the clothes in the absence of a sink (such refinements were not for us). In one corner stood a huge iron mangle with wooden rollers, underneath which was placed an old bath to catch the water.

I clearly remember a cellar running underneath the old wash-house. This was reached by deep stone steps, although we children were never allowed to go down them. I wonder if this could have been part of the old 'Dog Inn' which was burned down in 1887 when the thatched roofs on adjoining cottages caught fire. From an old painting hanging in the pub today it would appear that the cottages may have been attached to the 'Dog' running along Ivy Lane on the site of the present car park. The following report appeared in The Leamington Spa Courier on July 4th, 1887:

DISASTROUS FIRE – Shortly after six o'clock, on Sunday evening last a fire broke out in the village. The scene of the disaster was the Dog Inn. The only occupant of the house at the time was the landlord, Mr R. Neil. Mrs Neil and three of the children were in Scotland, and Miss Bickley and the other child had gone to church, while the servant was on a visit to her friends. Before the prayers were over at the parish church, an alarm was raised and brought the service to an abrupt termination. The first intimation Mr Neil received was an unusual noise upstairs, and on his proceeding to ascertain the cause he was met by a cloud of smoke. He then gave an alarm, but nothing in the bedrooms could be saved. The greater portion of the furniture in the sitting room and smoke room, including the piano, paintings, tables, and chairs was safely removed. In the construction of the house a large quantity of wood was used, and the roof was thatched. It can, therefore, be easily imagined how, after a month's dry weather, the fire would make rapid progress. A large concourse of people assembled, and little consternation was felt. The Southam fire brigade, under the command of Dr Holmes (Captain), arrived at half-past seven, but most of the damage was then done. They, however, remained until after one o'clock. The property, which is now a complete wreck, belonged to the Leamington Brewery Company. The damage may be estimated at several hundred pounds, but is covered by insurance. The origin of the fire is unknown.

The night before my mother's allocated washing day my father would fill the copper from our 'soft water' butt. One of those tall, wooden, iron-bound rain barrels stood outside the back door of every cottage in those days to collect the rain water that ran off the roof, providing an invaluable source of water, not only for washing clothes, but also for personal washing and bathing, hair washing and washing up. This 'natural' water re-

quired very little soap and felt soft and silky on the skin, no doubt earning the description of 'soft water' by which it was always known.

I have often noticed that many older village ladies of my mother's generation especially, have beautiful soft, clear complexions, perhaps because of this life long habit. I now live in a part of the world where, owing to the climate, lack of water is always a primary concern. Therefore, imagine my frustration when I see, during the rainy season, hundreds of gallons of this precious commodity flooding the roads, all going to waste. I remember these crude but functional storage vats of my childhood and wonder why it seems beyond the wit of man to arrange something similar along more modern lines to be supplied, built in as a basic part of each household.

After filling the copper, the fire would be laid underneath with dry kindling and small pieces of coal ready to light early in the morning. An early start was essential as washing clothes in those days was a long, laborious task. Everything was washed by hand. The water for rinsing was all drawn from the well, bucket by bucket. The 'whites' were put through a last rinse into which a 'blue bag' would be added. This was thought to give a 'whiter' finish to sheets and pillow-cases. No powder was used, everything was rubbed over with blocks of Sunlight soap. Collars, tray cloths, tablecloths, etc. were all put through a solution of 'Robin Starch'. After drying, these articles were sprinkled with water and rolled up ready for ironing (which took up most of the next day). After the laundry was completed, the wash-house would then have to be cleaned throughout, including the brick floor, ready for the next user. The whole exercise often took most of the day.

How lucky we are today, when all we need to do is programme a machine to do the lot whilst we go off shopping or sit with our feet up enjoying a cup of coffee. In this day of drip dry materials, a whole family wash can be washed, dried and ready to wear in an hour or so (and we think that we work hard!). How many of us today, I wonder, can still recall those miserable winter days when wet washing would be hanging around the kitchen and draped over the fire guard to dry for days on end?

Our front door opened from the street directly into the small front room. As was the fashion, this room was kept dusted and polished and contained the 'best' pieces of furniture, china ornaments, pictures and mirrors, and was only used on Sundays and other 'special' days such as Christmas, Easter and family celebrations. In front of the window stood a tall wooden plant stand on which reposed an enormous plant. I can't remember if it was the traditional aspidistra or a fern, but I can remember that it stood in a dark green edged, painted china pot.

A further door opened into the kitchen/living area. The steep narrow stairs running up from just inside the back door led to the two small bedrooms. The first merely a wide landing through which access was gained

to the further room facing onto Church Street, not allowing a lot of privacy. I see that these cottages now have windows in the attic areas. No doubt to allow for bathrooms, a luxury afforded to very few in the days of which I write.

We bathed in front of the fire in the long tin bath that hung on the wall alongside the soft water butt. The hot water was provided from a large iron saucepan and an equally large black kettle was always kept full of soft water, simmering on the hob. I can still remember on a cold winter's night, the joy of being lifted from the bath, then wrapped around in a soft, warm towel that had been hanging on the old fashioned fire guard along with our clean vests and nightwear.

I also recall with a shudder that revolting spoonful of Syrup of Figs that we were made to swallow after our bath each Friday night when our mother would quote the old saying 'clean inside and out'. This was supplemented later by an equally obnoxious concoction of Cod Liver Oil and Malt, a sticky substance that seemed to roll round and around the spoon for ever. We were also given a 'tonic' in the winter called Parrish's Food which I remember was red in colour and also tasted vile.

For an after bath treat in the winter, our mother would pop two large potatoes into the oven and serve them to us on a saucer, split down the centre, covered with melted butter and salt. There we would sit in front of the fire and eat them with a tea spoon, or sometimes there would be a hot bowl of bread and milk sprinkled with sugar.

There was no gas or electricity laid on, oil lamps gave us light downstairs and candles upstairs. In the front room we had a lovely lamp that hung from the ceiling. Set in a curly brass frame, the bottom part that held the paraffin was made of deep ruby red glass. The globe fitted over the long glass chimney. This was made of opaque glass, the lower half shading down from delicate to a deep pink on its fluted edge, the top half painted with birds and flowers.

The cooking was all done on the open top coal fire and baking in the small side oven. That oven was invaluable and used for a multitude of reasons. My mother's last job before going to bed would be to put a small bundle of sticks inside to dry out ready to light the fire in the morning. Bricks were also heated this way. Wrapped in a piece of old blanket, they made splendid bed warmers in the cold weather. On ironing days the flat irons were heated on a special trivet that clipped onto the bars of the fire grate. This meant that a fire would have to be kept going even on the hottest summer day.

Having no sink in the kitchen meant that personal washing, ironing, washing up, meal and baking preparations, along with a multitude of other chores, all took place on top of the old wooden kitchen table, the

forerunner of the working top. My mother's kitchen was a far cry from today's splendid kitchens – kitchens with row upon row of colourful fitted cupboards, gleaming double bowl sinks, waste disposal units, easy to clean tiled walls and a formidable array of machines ranged around the walls that, at the press of a button, will do almost everything, perhaps with the exception of clearing and laying up a table, but no doubt that will come in due course!

However, our old wooden table would be transformed each afternoon with the aid of a red bobble trimmed chenille tablecloth which matched the trimming pinned around the mantelpiece and a pot plant or vase of fresh flowers placed in the centre. On each end of the table was a deep drawer. The first held the everyday cutlery and the other clean tablecloths, tea towels, kettle and iron holders.

The 'privys' were ranged along the wall opposite each house. Although these arrangements were primitive by today's standards, at least we were lucky enough to have one of those small buildings allocated to each cottage and did not have to share one between two families as some did in those days!

I still recall the pungent smell of Jeyes Fluid, no doubt used in vast quantities to veil other more unpleasant odours. The wooden seat was scrubbed and bleached almost white. Hanging on a nail on the back of the door there was a quantity of neat newspaper squares, usually cut from The Leamington Spa Courier, threaded through a hole in one corner on to a piece of string. When I became old enough to carry out household chores for my Saturday penny, cutting and preparing this unique toilet paper became my job, along with cleaning table forks, spoons and knives (which in those days were not stainproof) with a pink powder dipped onto the end of a damp rag.

Mr and Mrs Tom Waring lived at No. 6. They had no children of their own and made a great fuss of myself and my brother, David John, who was born on January 1st, 1933. Mother often told us how she lay in bed listening to the sound of the church bells ringing in the New Year, just before his arrival. Mr and Mrs Ernest Austin resided at No. 5. They too were childless, so once again my brother and I came in for a lot of kind attention.

At No. 4, I remember a dear old lady, Mrs Smith. Mrs Smith wore an ankle length black skirt with a high necked lace trimmed blouse. She would take me onto her knee and sing to me. My favourite song was 'Daddy wouldn't buy me a bow-wow'. She gave my mother a lovely old silver thimble which I still use today.

Next door, at No. 2, lived my father's sister, Enid, and her husband, Uncle Frank Bayliss. Auntie Enid was my Godmother, and I will always

remember her with great affection. One of my earliest memories involves kneeling up on a cushion on the seat of a chair at the end of the big scrub-topped table in her kitchen watching her mixing cakes and pastries, including her speciality – coconut pyramids. These were all cooked in the coal heated oven. Sometimes I would be allowed to cut the strips of pastry to trim the top of a delicious treacle tart and would wait with bated breath to see if there would be any scraps left over for my own use (there always were), the result of which would be a much handled, grey, sticky looking jam turnover, carefully placed on an old saucer, brushed over with milk and cooked for me to take home. The little kitchen was always cosy and warm with a bright coloured 'peg' rug on the floor in front of the sparkling black-leaded firegrate. The usual huge black kettle would be steaming away on the hob providing a constant supply of hot water for washing up 'as we went along to make the job easier' my aunt would say, and the mouth-watering smell of baking would pervade the air.

Among the various pictures on the walls was one that fascinated me. It was housed in an ornate gilt frame and depicted 'The Death of Nelson' in all its gory detail of mangled bodies, and smoking canons, with Hardy supporting Nelson in the moments before he expired. I remember I would try to keep my head averted but somehow it seemed to hold a morbid attraction and I would find my eyes returning to it again and again. I often wonder what became of that picture, no doubt thrown out along with other 'rubbish' that now commands a fortune in the so called 'antique shops'.

In the end cottage, No. 1, were Mr and Mrs George Savage with their daughters, Barbara and Helen. Barbara and I were similar ages, as were David and Helen, who were always fighting and squabbling. One day during a particularly fierce exchange, David bit Helen through the arm leaving behind a bad bruise and a complete set of teeth marks. Our mother immediately did the same to him remarking "Now *you* know what it feels like". He never did it again!

Today, such old fashioned discipline would be regarded with shock and horror by the hordes of highly paid social workers and child psychologists who seem to play a major part in our children's welfare. My mother's actions would possibly have been noted in some official quarter or another and she described as an 'unsuitable parent'. Like 'big brother' these 'officials' have taken over the role of parental control and discipline, often with disastrous results. Recently I heard of a seven year old who, when admonished for a minor crime by a loving grandmother with whom the child has a great relationship, remarked quite seriously "You are not allowed to hit me. If you do I shall tell my teacher and you will go to prison". What a sad reflection on today's society.

I for one am heartily sick and tired of hearing excuses made for young

offenders who mug and beat up old ladies, steal and smash up expensive cars and damage property, only to receive a rap over the knuckles when some 'do gooder' stands up and bleats about the culprit 'coming from a broken home' or 'being dropped on his head at birth'! Things have come to a pretty pass when the offender gets all the help and sympathy and not the offended!

Barbara and Helen had a rag doll that had been made out of a pair of old black stockings. Topsy had a thick, black wool plait of hair and embroidered eyes, nose and mouth and wore a red spotted dress and knickers which 'came off' as did her knitted boots and hat. How I coveted that doll. I thought that she was the most beautiful thing that I had ever seen. Once when I was ill in bed with a sore throat to my delight I was allowed to keep her until I recovered.

George Savage was Dr Pirie's chauffeur and wore a smart uniform which included a peaked cap. We children were terribly impressed and would line up on the path in Church Street just to watch him drive away in the big black shiny car, feeling very envious of his daughters on the odd occasion when they were given a ride as far as Alcock's Field opposite the church wall.

As the depression of the 1930s continued, my father remained unemployed. The dole money for a family of four was then twenty-two shillings a week. The rent for No. 3 Church Street was half-a-crown. These small cottages now sell for something in the region of £60,000. Dad took any odd casual work jobs that he could get, mostly daily farm work, to subsidise this meagre income. Sometimes he would receive a little money, sometimes payment in kind such as half a dozen eggs. Then there would be a boiled egg each for tea.

He managed to acquire an allotment on Churchlands where Cecil Bloxham now lives, and Mr Moore has his farm buildings. The tough training he received as a boy from his father when he learned his skills as a gardener now came into their own. He grew plenty of fresh vegetables which my mother would turn into nourishing meals with the rabbits that he snared on these allotments. To provide a change, she would occasionally stuff and roast them. In later years I often heard her say "I never want to eat another rabbit as long as I live" and I don't think she ever did!

Another cheap dish that remains a family favourite today was 'Bacon Jack'. Mother would tell us that in those days it was possible to buy a good amount of bacon 'bits' for tuppence from 'Moles' shop. These bacon bits were the small pieces that fell underneath the old fashioned bacon slicer. She would chop them with onion and parsley. Enclosed in a suet pastry, then boiled in a floured cloth it tasted delicious.

Mr and Mrs Mole and their daughter Eva kept the general store in

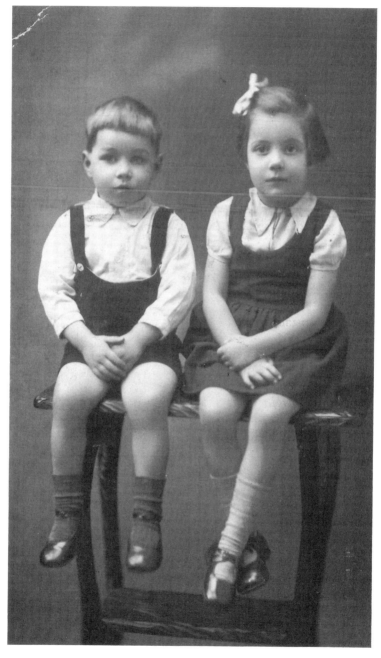

Brother David John and me – 1936

Church Street, now known as 'The Top Shop and Post Office'. Sometimes, for a special treat, David and I would be given a halfpenny to spend. Our mother would boast that almost as soon as my brother learned to walk he would totter up the path to the shop where he would bang loudly on the door until Eva opened it, he would then hand her his halfpenny, then proudly make his way back to No. 3, carefully carrying his bag of sweets.

There was little money to spare for extras, but our mother always made Sunday tea an occasion. There would be an orange jelly made with a tin of mandarin oranges or a pink fruit blancmange. She would make scones and a sandwich cake spread with a thick layer of homemade jam or, for a special treat, if she could spare the butter, tiny butterfly cakes topped with buttercream and jam or mouth-watering shortbread. Each Sunday she always made a large 'cut and come again' cake which was my father's favourite. Small treats by today's standards but to us then, a feast fit for a king. My mother was an excellent cook, she never measured or weighed any of the ingredients and only ever used an old version of the 'Bero' cookbook, which I still use today. How sad that the art of enjoying life on very little seems to have disappeared.

Another weekend treat was Sunday morning, tea in bed, when we were allowed to climb into the big double bed with both of our parents. Whilst Mother was downstairs making the tea, we would beg our father to sing to us. This he would do in between drifting back off to sleep when we would shake him awake again. I can still remember those songs – 'Down by the Station' – 'Horsey Horsey' – 'Mammy', when he would mimic Al Jolson whom he had seen in the first talking film entitled 'The Singing Fool' when it was shown in Coventry and, of course, his favourite cowboy songs – 'Heading for the last Roundup' and 'Old Faithful', two of a series recorded by a group called 'Sons of the Pioneers'. I suppose even this would be frowned upon today by those selfsame 'child experts' of which I spoke earlier who I understand have condemned Enid Blyton's Noddy and Big Ears as sexual deviants for sharing the same bed!

After breakfast, Mother would carefully dress us in our Sunday 'best' clothes and shoes then, leaving her to do her baking and cook the Sunday dinner, Father would take David and myself for a walk. We usually made our way towards Childyke along the railway banks or down the other way, past the mill, then over the stile and across the fields coming out just below our granny's cottage in Mill Street. Granny's house was situated at the end of Dark Lane, or Back Lane as it is now known. Granny would be busy cooking the dinner. On a high wooden stool in front of the fire would be the joint of meat, keeping hot, surrounded by a ring of roast potatoes and onions on a large blue and white meat dish. The smell of the Yorkshire pudding cooking in a bed of meat fat and juices, cooking in the oven,

would fill the air. On the table, spread with a snowy white cloth, would stand a large sugar sprinkled fruit pie and a glass jug full of creamy custard, covered by a saucer 'so as not to form a skin' my granny would say. The saucepans of vegetables would be simmering away on the side of the fire and the plates would be down in the hearth where they had been placed to warm through.

For some reason I was afraid of my grandfather, Edmund Mann, who would be sitting by the side of the fire in his high backed wooden chair. Perhaps this was because he was very deaf and spoke in a loud voice. Indeed, everyone around him always seemed to shout and to me, as a small girl, I think in retrospect, must have found it very intimidating. In contrast, my grandmother was a softly spoken gentle lady with a wonderful smile.

It was during this time that Mother obtained a post as a general help, working for Mrs Charles Farley of Wissett Lodge, that superb 17th century house with its original stained glass and stone flagged floor. (How my mother hated that floor which could only be cleaned by using a bucket of soapy water, a large floor cloth and a thick kneeling pad!). Before her marriage to my father she had been employed as a parlour maid at Flaxhill House, Ufton, and so it followed that when Captain and Mrs Farley gave a special dinner party she would be asked to wait at table and when they entertained on a larger scale, she would also attend. I can see her quite clearly in my mind's eye, a small, pretty, dark-haired lady, trim and neat in her black dress and white muslin cap and apron.

David and I have many memories of the happy times we spent at Wissett Lodge. On these exciting evenings we would sit together in the kitchen in a big basket chair watching the frantic activity going on all around. Margaret Thacker, the cook, a plump, red faced, jolly lady produced the most delectable food, all cooked on the big old fashioned range. Exotic dishes with names completely foreign to our ears. Names such as Grilled Spatchcock, Jugged Hare and Angels on Horseback. These were served along with shimmering jewel coloured jellies, delicious individual desserts, superbly decorated with whipped cream and chocolate, ice creams and meringues.

What splendid occasions these were, when the gentlemen wore formal dress and the ladies were decked out in gorgeous evening gowns, floating delicate creations in all colours of the rainbow. The sound of music and laughter would sound throughout the house, overflowing into the kitchen, creating a festive air which rubbed off onto the staff. Edie Finch, the young maid who came from Bishops Itchington, would scurry to and fro with little snippets of gossip describing the guests and what the ladies were wearing.

Chaos seemed to reign throughout the kitchen until the last course was

served. It would then be time for clearing and washing up (no dishwash-ers). But eventually all would be clean and tidy. The glass, china and silver all carefully stacked away in the appropriate cupboards. Once this was completed, it was our turn to sit down at the big kitchen table and tuck into the leftovers. Often Margaret would fill a basin or two for us to take home for our dinners next day. I have often thought that these occasions must have been a welcome diversion for my young mother who was only then in her early twenties, bringing a little excitement and laughter into her life during those times of great financial hardship.

I imagine that Captain and Mrs Farley were charming and generous hosts. My recollections of Mrs Mavis Farley are of a very gracious lady who never failed to visit the kitchen and thank all concerned for making the evening a success. She would bring along a large box of chocolates, milk and plain I remember, from which David and I would be invited to choose a selection to take home. What a treat in those days of our enforced austerity!

Two other visitors to Wissett Lodge that I remember well were Mrs Tottenham, Mrs Mavis Farley's mother, and her sister, Miss Merle Tottenham. They would bring along their little dog, a fat little Dachshund, known by the unfortunate name of 'Misery'. Merle Tottenham was an ac-tress who took part in plays and films in the 1930s and 40s. Such produc-tions as Noel Coward's 'Cavalcade' with John Mills, who was even then being acclaimed for his great talent as an actor, 'Duet for Two Hands' by Mary Hayley Bell (who was later to marry John Mills) starring Jack Hylton and Jack Buchanan.

She appeared in the Hollywood film production of 'Night Must Fall' in 1937 starring Robert Montgomery, Rosalind Russell and Kathleen Harrison, and the famous stage play and film 'This Happy Breed'. In the 40s she appeared with George Formby in comedy films such as 'I Didn't Do It'. It was interesting to note on reading an old programme that a box for six people at The Drury Lane Theatre in the 30s cost four guineas and two shillings and eleven pence for a seat in the front stalls! Another theat-rical connection with the Farley family is their cousin, the famous Ninette de Valois.

During the summer, when the family was away, extra special cleaning took place. David and I would then play in that delightful garden and or-chard along with Margaret's niece, Dorothy Thacker, from Bishops Tachbrook, who always came over to Harbury to spend a holiday with her aunt. During these weeks of frantic household activity we were allowed to play in the schoolroom on wet days. I remember a wonderful wooden rock-ing-horse and a doll's pram that turned into a cradle when the wheels were removed. We also gave 'dolls' tea parties'. Margaret would provide minute

iced biscuits and real home-made lemonade to fill the tiny teapot from which we would carefully pour this delicious concoction into miniature china cups.

What golden days they were and what memories came flooding back when on a recent visit home I was invited to look around by Mrs Sperling, or 'Miss Pam' as I remember her, the daughter of the late Captain and Mrs Mavis Farley, who now resides at Wissett Lodge. Although some changes have been made over the years, both inside the house and grounds everything more or less remains the same as I remember. As I walked up the gravel drive I could almost see old Mr Baker, the gardener who lived in Temple End, making his way towards the kitchen carrying a huge trug full of freshly picked vegetables. He was a dear old man, as deaf as a post and whenever we spoke to him, whatever we said, even if it was just 'good morning', he would respond by taking a large turnip shaped watch from his waistcoat pocket and proceed to tell us the exact time. The old medlar tree still stands in the middle of the lawn, as does the ancient mulberry tree at the end of the garden, reputed to be about 250 years old.

Captain Farley was an avid sun worshipper and at every opportunity would take advantage of the summer sun, lying on the grass completely unclothed. That part of the lawn was fenced in by a thick wattle fence, giving complete privacy. It was impossible to see through it, however, whenever he was wanted on the telephone Edie would cover her eyes with both hands as she approached and, standing behind the fence, would announce in a loud voice "you are wanted on the telephone Sir" and would not remove her hands until she arrived back inside the house.

Mrs Farley, as I have said, was a very generous lady, therefore, I inherited outgrown articles of clothing that had belonged to her daughters, Miss Pam and Miss Ann. By far the most memorable garment was a stunning white crepe de chine dress, tucked and smocked and liberally trimmed with lace which I wore with great pride on Sundays for 'best', complemented by a pair of black patent ankle-strapped shoes and a pale green straw hat trimmed with artificial daisies.

These early recollections I would describe as golden years full of happy memories. Memories of loving young parents and a small brother who was always willing to share his meagre sweet allowance and would meticulously count them out into two equal piles. He would often pay a visit to the Vicarage to pay his regards to the Rev Capps and when asked by that kindly man "Would you care for an orange or an apple David" would invariably reply "One of each please, and some for our Frances"!

Chapter Three

FRANK CECIL MANN: 1907–1975

I dearly loved and respected my father. A true salt of the earth country-man with the blood of hardworking forebears running through his veins. Men and women who had lived out their lives working on the land, thus contributing to the history of that small area of Warwickshire between the villages of Chesterton and Harbury.

His knowledge of the countryside, birds, animals, trees and flowers was vast, knowledge that had not been accrued from hours of poring over text books to gain a prized academic title, but knowledge that had been handed down from father to son over countless generations.

He was born at the beginning of the century, the sixth child in a family of ten, four boys and six girls. A family ruled with a rod of iron by a stern father, offset by a gentle, loving mother. He would speak with great affection of his brothers and sisters. They were a close industrious family, the girls were given allotted tasks to carry out indoors under the supervision of my grandmother, likewise, the boys outside the house superintended by my grandfather. In true Victorian style the girls were brought up to wait upon the boys, even to the extent of cleaning their boots! They cooked, cleaned, sewed, washed and ironed, the elder ones helping Granny to look after the younger children.

The boys did gardening, fed and cleaned out the poultry and the two pigs that were housed in a sty at the bottom of the garden, fattening up for the house. They collected wood and sticks from the hedgerows to burn in the black-leaded firegrate, ran errands for neighbours and did any other odd jobs that they could find to bring in a few extra pennies to supplement the family budget. For a year or so before my father left school at the age of twelve, he walked down to Harbury Station each morning to collect the newspapers, delivering them before school.

His first job was as ploughboy at Willowbrook Farm for Mr Wincott, a farmer whom he always described as 'a good old boss'. The hours were long and the work hard. It involved walking behind the plough all day in all weathers, with only a sack bag over his shoulders to keep him warm and dry. In those days, of course, if the weather was so bad that farm workers were unable to work they would be sent home and only receive wages for the hours worked, unless they had a 'good old boss'. On such days as these it meant that he would face the long walk home, still wearing the soaking

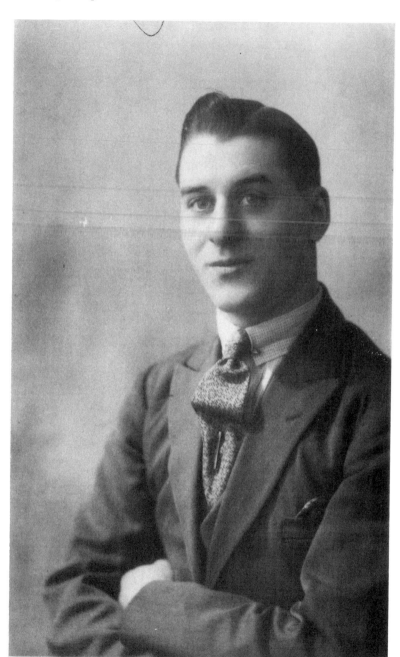

Father aged twenty-one

wet clothing that he had worn all day. I often wonder if this contributed to the arthritic condition which started quite early in his life and was later to develop into a more serious illness which eventually rendered him completely immobile.

The family lived in the cottage No. 29 Mill Street, now known as 'Barn Cottage'. A small dwelling indeed by today's standards to house such a large family. However, the older children left home after finishing their schooling, the girls to go into domestic service and three of the boys to enter the Regular Army. This must have relieved the accommodation situation enormously. There were no 'mod cons' but my father would tell us with pride that although facilities were primitive and money scarce, they were all well fed, well shod, scrupulously clean and neatly dressed.

Granny made all of the children's clothes. Nothing was ever thrown away and outgrown garments would be washed and then carefully unpicked, the worn parts were then cut away and the best parts reserved for making trousers and jackets, often resulting in a finished article made up of different materials and colours, I would think a little like Joseph's coat! Small unwanted scraps of material were cut into strips and 'pegged' onto a sack bag that had been opened out and washed to form the backing for a warm rug for the hearth or bedroom. This was a job that all the family would take part in, particularly on dark winter evenings around the fire by the light of the oil lamp.

My grandfather, like all countrymen in those days, was an excellent gardener. He had two strips of allotment down Mill Lane, known as Childyke, where he grew vegetables and tended his fruit trees and fruit bushes. At one time he also had a further allotment at Harbury Heath. These particular pieces of land were allocated for the villagers' use at the time of the enclosures and as a child I remember they were still in use. They were situated on the left hand side as you enter the gate, now leading to Chesterton, through the old Kingston Manor Estate, on the junction of Beggars Lane/Plough Lane/Harbury Heath. There my grandfather grew mainly wheat or barley for feeding his pigs and hens. Along with the vegetables that he produced and the rabbits that he snared, plus the home produced ham, bacon and eggs, he provided a nourishing diet for his growing family.

My granny made large Yorkshire puddings, bread puddings and suet dumplings filled with home-made jam or stewed apple from the Codling tree, and Beestings, a kind of milk pudding made with the first milk from the cow after the birth of a calf. Sometimes, for a special treat, my father would tell us that he would be sent to one of the village bakehouses (there were four in those days) to fetch a halfpenny worth of treacle in a clean basin. This they would eat with great relish on thick slices of crusty baked bread, fresh from the oven.

When a pig was killed the whole family ate like lords. No fridges or freezers in those days, of course, therefore the pigs 'fry', meat and home-made savouries that could not be preserved or eaten by the immediate family was shared out between relatives and friends, who would recipro-cate when their own pigs were killed. This convenient communal arrange-ment, supplemented by the wild rabbits and boiling fowl which had 'gone off the lay' meant that fresh meat was nearly always available for at least one good meal a day.

On pig killing day my granny would start preparations in the early morn-ing by first filling and lighting the copper to provide plenty of hot water. She would then make ready the large pans kept for making lard, flavoured with rosemary, black puddings, faggots, huge pork pies and boney pies, thick with delicious savoury jelly made from the pig's bones and covered with mouthwatering pastry, and brawn made from the pig's head. The chiddlings, or intestines, would be turned inside out and washed in salt water several times, then left to soak for three days, after which they would be washed again, plaited together and cooked with onion to be eaten with vegetables and served as a main dish. The pig's trotters were considered a delicacy and were eaten at suppertime with bread and butter. The children were given the bladder to use as a football and would eagerly await the scratchings which they ate sprinkled with salt. These were the residue left behind when the rendered down fat had been strained off to set into pure lard. My father would say that the only part of the pig that was not utilised in some way was the grunt!

Each year after the farmers had gathered in the harvest, my grand-mother, along with other village women, would go leasing or gleaning for the odd ears of corn that had been left behind by the reapers. The older children would help and small babies were carried along wrapped in shawls that were knotted across their mother's shoulders. The result of their la-bour was the small sack of flour which they would proudly bear home af-ter the corn had been ground at the mill. There was quite a competition to see whose sack contained the most flour. I would imagine a lot would de-pend on the number of children in a family and also how energetic they were!

The fruits of the field and hedgerows were gathered from which home-made preserves, wines and cordials were made. Housewives made their own cough cures and ointments for sore throats, chilblains and other com-mon complaints. Goose grease, mustard and fruits containing Vitamin 'C' such as blackcurrants and rose hips were some ingredients that I remem-ber were used by my own mother when we were children.

Nothing was ever wasted, potato peelings, the outside leaves of green-stuff and root vegetables were fed to the pigs and hens, and household

table scraps to the domestic pets. A far cry from the expensive array of tinned dog and cat food available from the mind-boggling display in today's supermarkets, purchased to the tune of several million pounds each year.

Those were the days when country folk were truly living off the land. Today one can hardly pick up a newspaper or magazine without reading some article or another warning us of the dire consequences of eating too much animal fat, red meat, sugar and eggs, urging us to 'lower our cholesterol levels' and 'take more exercise'. However, in those days of which I write there was no danger from colourants and additives, or fear of contamination from pesticides or meat from animals force fed on drugs to fatten them up or to produce a leaner or more tender cut of meat for the gourmet. There is no need for me to elaborate. We are all aware of the unspeakable cruelty inflicted by man on God's creatures, hiding behind the name of science, which can usually be interpreted to read 'big business'.

In the materialistic world the balance sheets of the huge drug companies bear this out only too well! Animals that were meant to live a natural happy life are now cooped up in confined spaces, never seeing a blade of grass for the whole of their short lives. I often wonder what my ancestors would think of it all were they to return to earth. I am quite sure they would be saddened by this state of affairs. In days gone by there is no doubt that country folk worked hard and long, but they seemed to have an inborn affinity with the land and its other inhabitants. On the question of exercise, my father's family's diet of homegrown vegetables and fruit, plus the enforced exercise of 'Shank's Pony' soon restored the balance in spite of all that fat, homecured bacon and pure suet puddings.

Times were hard and the ever-present threat of the workhouse still hung over the heads of unmarried, pregnant girls, widows, the elderly and infirm and other unfortunates. The nearest workhouses were situated at Warwick and Southam. Conditions in these institutions have been well documented in detail by such nineteenth century writers as Charles Dickens in his writings of social history showing his great compassion for the plight of the poor.

Southam workhouse was built in 1838. The men and women were housed in separate quarters, thus married men and their wives and families were unable to stay together. Inside was provided a schoolroom for children and a hospital ward for the sick. Homeless men were also given one night's lodging. In the late 1920s, early 30s, the building was converted by the Southam Council into twelve units for the homeless and problem families and was named 'The Dwellings'. I can remember visiting there in the early 1950s and recall a cold, cheerless building with long stone flagged passages resembling a rabbit warren. The original stone seats were still in

place ranged around the walls of the gloomy entrance hall retaining that bleak Oliver Twist like image.

My grandfather, Edmund Mann, as I have mentioned was an extremely strict father. When he said 'no' he meant just that! My father used to tell us that no amount of pleading would change his mind once he had made a decision. As our father and his siblings became older they obviously enjoyed taking part in the limited social life that was available and he often related the tale of the time they all wanted to go to a dance that was being held in the 'Hut' at Chesterton. This was a wooden building that I think was situated on The Green. My great aunt, Elizabeth Mann, who was our last family link with Chesterton, was the caretaker. Aunt Elizabeth worked as a dairymaid at Hurdis's Farm for the Thwaites family and remained living at the tied cottage, No. 1 The Green, until her death well into her eighties. After much discussion, my father was elected spokesman and sent into the garden to approach Grandfather Mann who was chopping wood. He put forward their request and thought he had delivered a well prepared speech covering all areas likely to jeopardise their request – assuring him that the boys would chaperon their sisters for the whole evening, and they would accompany them on the walk there and back. Grandfather continued to chop away, listening to the petition in silence and never spoke for several minutes after, then, leaning on his axe he said "You see that there tree out there in the jitty, boy. Well fetch 'em all out and dance round that. None on yer wunt come to any 'arm doin' that an' that's the only dancing yorl do ternight". End of conversation!

My grandfather, Edmund John, was the son of John who was born at Green Farm, Chesterton, where the family had farmed since way back. When he married it became apparent that the farm would not support a wife and family and several unmarried brothers. He branched out on his own as a butcher, living for a short time in the village of Tysoe, eventually moving to Pillar Box House in Farm Street, Harbury. I remember as a girl a lovely old double-fronted stone farmhouse, with a huge built-in barn and loft with enormous tall wooden doors reaching the full height of the building. This was yet another piece of village history demolished in the late 1950s/60s to make way for a road through to the new estate 'Sutcliffe Pastures' and a doctor's surgery.

On his retirement, he and my great grandmother moved into a small thatched cottage at 'Park Lane Pit'. Later, as a widower, he went back to Chesterton, there to reside with his daughter Elizabeth, who never married, and lived to a ripe old age, well into his nineties.

Dad, as a young boy, would accompany his grandfather, John, on his long walks visiting the surrounding villages where he slaughtered the farm animals and cottagers' pigs. One story he often told us was of the time

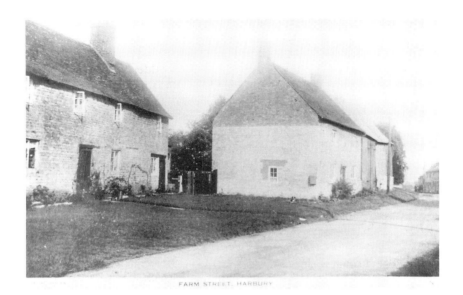

Pillar Box House, Farm Street, on right showing tall wooden barn doors

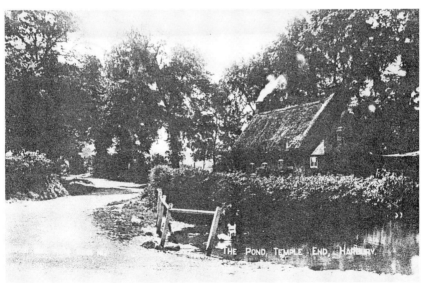

Reproduced from Postcard, Warwick Records Office

Park Lane Pit and old thatched cottages
corner Bush Heath Lane

when, after a long day, Grandfather John reached Chesterton Mill Pool, his last call of the day. By then dusk was beginning to fall, and after he had dispatched the pig, the miller and he agreed upon a price for the job and the miller insisted that the deal be sealed the usual way with a drink of home brew. Taking into account the time of day and the fact that he had undoubtedly received the same hospitality from each farm and cottage he had visited during the day, little wonder that in the darkness he took the wrong turning and fell into the mill pool. After a great deal of huffing and puffing, pushing and shoving, and amid many unprintable comments, he was pulled out of the water still clutching the tools of his trade, wrapped in sacking, clutched to his chest. He was reputed to have said when invited back inside the house to dry off "Never moynd about me bloody trousers, it's me tools as matter".

Drink seems to feature in quite a few family anecdotes. Another story that Dad told us was corroborated by the late Bert Hillyard years later during a conversation concerning the old days in Chesterton. One of John's brothers, I believe it could have been Alfred who died aged forty-five in 1892, had been to Warwick market. On the way home, in the dark, the horse was thought to have stumbled on the rough, unmade road as it would have been then, or may have pulled a wheel of the trap into a deep rut. Poor Alfred fell into a ditch and was found the next morning with a broken neck caused by a huge barrel of beer that he was taking home falling across his back. Bert chuckled and with eyes twinkling said "You could say, as 'ow the drink killed 'im".

The men in our family have always enjoyed their glass of beer. My brother tells tale of a few years ago when he and his family drove down to the Isle of Wight to visit Uncle Eric, my father's brother, where he lived after his retirement. He and his family travelled overnight, arriving very early the next morning. Uncle Eric met David at the door and immediately offered him a drink. He eagerly accepted, thinking a welcome cup of tea was at hand. Uncle Eric, however, had other ideas. Proffering an enormous glass of neat whisky he remarked "You ent a Mann if yer can't tek yer drink".

Dad also enjoyed a glass of beer (or two) and often when he returned from the Dog Inn or the Clubroom on a Saturday night would give us his rendition of 'Among my Souvenirs', 'South of the Border', 'When the Red Red Robin comes Bob Bob Bobbing' and other such masterpieces, on our old piano. His favourite song was 'Ramona'. I can never listen to this without seeing a mental picture of Dad playing away and singing to his heart's content. He was quite a good pianist considering he had never had a lesson in his life. I gathered that when he left home in the 1920s to work in Coventry he would help out in a pub belonging to a relative of Granny

Mann's. This is obviously where he had learned the art of the keyboard!

A man of few words, he was scrupulously honest and fair in all his dealings, he expected the same courtesy from others. To use his own words "Anyone who pulled a 'flanker' over him would never be forgiven". A classic example of this was the fact that he never once, in my hearing, spoke a word to his elder brother, Bert. I could never understand this and asked my father several times over the years the reason for this. He always replied "It don't matter. *He* knows why". My mother once told me that it was all over half a crown that Uncle Bert had borrowed and had never repaid. I don't know if that was the true story or a convenient answer to my persistent childish questioning. I often wonder if either of them could even remember the details after such a long time!

Stubbornness seems to be an inherited trait in our family. Some of us still find it hard to forgive or to say 'I'm sorry'. I can only hope that with approaching 'old age' we mellow a little. Hurtful remarks that would have wounded or offended me when I was younger seem much less important now. Perhaps we develop a thicker skin along with our wrinkles and grey hair; or do we learn to accept people for what they are and not what we would expect or prefer them to be?

When Dad was a young man there were only a few privately owned cars. Among these lucky individuals were Dr Sutcliffe, Dr Pirie, Mr Alcock – the butcher, and Colonel Kitchen who lived at Harbury Heath owned a dark red Sunbeam plus a Trojan runabout which had solid wheels and was chain driven. Bill Calloway, who lived next door to my grandmother in Mill Street, worked for Col Kitchen and was allowed to drive home for his dinner each day. His sister, Mrs Joan Clarke, remembers that when her mother heard him turn into Park Lane with the engine chugging and much grinding of gears, she would dish up his dinner and it would be on the table when he arrived home! Mr 'Pop' Harris who lived in Chapel Street and was organist at the church was the proud owner of a Bull Nosed Morris. This had a dicky at the back which opened out to seat two people.

Most deliveries from the local shops were made by horse and trap. Flour was brought to the bakeries by a Foden's steam lorry and the beer from Flowers brewery drawn all the way from Stratford-upon-Avon in a dray pulled by four shire horses. There they would stand, wearing their nose bags containing their oats blowing out huge clouds of chaff, patiently waiting whilst the barrels were unloaded and rolled down to the cellars below. The horses would be wearing those beautiful horse brasses, now much sought after as collectors' items. Wilfred Potter from Bishops Itchington would deliver fruit and vegetables in and around Harbury in his flat horse drawn cart hung around with rabbits at 9d for a small one and 1/- for a large one.

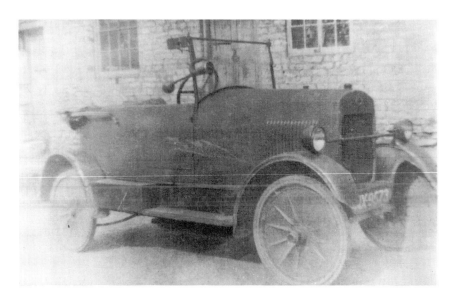

Col. Kitchen's chain driven Trojan car

Great Aunt Liz Mann taken outside 'The Hut' on Chesterton Green

Jobs were scarce, the time of the Great Depression had arrived. Along with thousands of others, Father was 'laid off' from his job at the Morris Motor Factory in Coventry where he was living in lodgings. He returned to the family home and would cycle to Coventry and back to Harbury each day looking for work, starting off at 4 am, nearly always unlucky. When he returned home he often worked the rest of the day for a local farmer. The man who shall remain nameless was not known for his generosity and would reward him with a few eggs and a pint of milk. Not such a 'good old boss'. Men were desperate for work and would consider any menial task to earn extra money to supplement their 'dole' money. That was when unscrupulous men such as I have just mentioned took unfair advantage of the plight of the unemployed.

Mrs Calloway organised the first fresh fish delivery in Harbury. She acquired a hand cart and a large pair of scales and ordered the fish to be delivered each day. It came via Harbury Station, packed in huge chunks of ice. Orders were taken and delivered by her son Bill, who was then also unemployed. Bill and daughter Joan would then push the cart around the village selling from door to door.

These were hard times with no huge social service hand-outs that now seem all too readily available. I wonder how some of the population of to-day would fare? Those that live for years abusing the authorities with supposed 'back problems' and similar complaints that seem to remain with them for years. These parasites upon society still manage to find the strength to visit the pubs and clubs daily, drive a car, and take holidays abroad. Things seem to have gone from those days of genuine hardship to the other extreme. Unfortunately, as I see it, children learn by example the standards set by their parents and, therefore, will see nothing wrong in continuing this way of living.

To say that Dad was 'careful' with his money is an understatement. This, of course, was a direct result of those lean times that he and a million others experienced. Saving for a rainy day became almost an obsession and he would often say that he would be prepared if 'those times' ever came again. One of his favourite sayings was "With a pound in your pocket you always have a friend". Not understanding the significance of these words as a child, I remember thinking that a *real* friend should be a friend even if you had no money at all!

He was totally against any form of hire purchase, extended payments or 'tick' as he would call it. In his book you didn't get it until you had saved the cash to pay for it and then you only bought it if you really needed it! I remember David and I becoming the proud owners of two secondhand bicycles that our aunt had secured for us from the lady of the house where she was in 'service'. They cost ten shillings each. Quite a sum I suppose in

those days. Dad gave us our first lecture ever on the art of economics and made us promise that if he bought them for us we would pay him back however long it took us to do so. At the time it seemed an impossible task seeing that we only received one penny pocket money each Saturday.

A short time later he purchased a newspaper round from Mr Harold 'Topper' French, who lived in the end house in 'Golden Row', now known by the more upmarket name of 'Park Lane Terrace'. For almost two years my brother and I delivered those newspapers before school to houses as far apart as Harbury Heath and Northfields Farm, Ufton. We also took the Leamington Spa Couriers around the village on Fridays after school. David and my father delivered the Sunday newspapers to Ufton and Bascote Heath after collecting them from Harbury Station. My father sold the newspaper round to Mr Cuthbert from Kineton who started the news-paper shop at the old Post Office when he took over from Mrs Cooper, an old lady whose family had lived in that house and had run the Post Office since the early 1800s. As we never received a penny piece during all that time for our hard work, out in all weathers, we reckoned that we had worked off our debt!

Dad was extremely knowledgeable about the history surrounding our small part of the world. He loved to tell us stories of the Civil War and the battles that were fought such as the famous Battle of Edgehill. He knew many details of the local churches that were desecrated by Cromwell's army and would take us to inspect the marks left by cannon balls and tell us of the stained glass windows and other priceless objects that were re-lentlessly destroyed by the Roundheads. He would relate with great glee stories of that period of history in which the Royalists always seemed to outwit Cromwell's men.

I have often wondered if much of this information had also been handed down by word of mouth over the generations. After all, it is an historical fact that our part of the world was a Royalist stronghold. We are proud to acknowledge that our family name, Mann, is present in every record since 1642 when the Protestation Oath Returns of that year were taken at the outbreak of the Civil War.

Dad's allotment was his pride and joy, with rows of vegetables spaced out looking for all the world like soldiers on parade, fat pods of succulent peas, runner beans climbing up a carefully woven wall of sticks. Weeds were never allowed to flourish and would be dispatched swiftly with a sharp chop from his hoe as soon as they appeared above the ground. I can close my eyes and still taste those delicious fruits that we would gather from his garden for the first mixed fruit tart of the year. This our mother would cook for Sunday dinner, served with a bowl of thick creamy custard. Black and red currants, gooseberries, and loganberries. Then, of course,

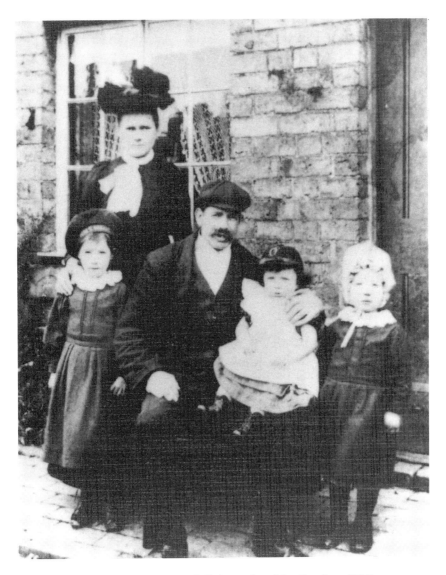

Granny Mann's brother Will Attwood and family – late 1800's

there would be the juicy raspberries and strawberries which we ate sprinkled with sugar and covered with the top off the milk. Sharp tangy rhubarb made into a mouthwatering pie, cooked with slivers of lemon peel. The pink Victoria plums and Golden Magnum Bonums would be gathered and 'bottled' for the winter or made into jam.

I cannot think of any vegetable that Dad didn't grow. In his small green-house he produced the most delicious tasting tomatoes. I can honestly say that I have never since found any to equal those firm orange/red beauties with their distinctive flavour. He grew most things from seed, often from his own produce and each year he would save potatoes and carefully lay them out on wooden trays to 'chit' ready to replant the following year. My mother carried on the tradition of country folk by turning out umpteen pots of jam and jellies, pickles and chutneys. These would stand on the pantry shelf alongside the tall earthenware pots of pickled shallots that Dad had patiently peeled with his small pen-knife sitting by the kitchen fire in the evenings when it became too dark to work outside. I remember that he often took along a raw onion to eat with his lunch of cheese sandwiches. He always said that plenty of raw onion prevented the common cold and when I look back I can never remember him suffering from that common of all ailments.

His garden tools gleamed like new and were kept in an immaculate con-dition. Always after using his fork or spade he would first scrape them with a small sharp piece of wood then rub them all over with an oily rag. He would say "A good workman always cares for his tools and, anyroad, it meks the job easier". He was always quoting old country sayings and could usually find one to fit most situations. For instance, he would often lecture David and myself on the advantages of early rising, quoting the old adage "An hour before seven is worth two after eleven".

The care he took of his garden tools was reflected in everything he did – "If a job's worth doing, it's worth doing well" he would say. His garden shed, or 'hovel' as these small buildings were called by country folk, was always tidy and neat. Hung around the walls were his garden tools, his screwdrivers, brace and bit and choppers and axe. Hanging from the roof would be huge wreaths of onions plaited together in the old fashioned way that his father had taught him. Mrs Joan Clarke told me that, as a child, she could remember how my grandfather always kept his wreaths of on-ions hung high up inside the fowl house to keep them dry.

Around the edge of the floor were the sacks of potatoes that he had grown for eating as well as the sacks of 'pig potatoes'. These were those that were too small for domestic use and were cooked each day and mixed with Sharp's meal to be fed to the hens. David and I loved to eat these tiny potatoes, hot straight from the saucepan. The Sharp's meal was stored in a large tea chest in a corner and I remember that often we would see a small field mouse scuttle across the concrete floor when we disturbed him eating his illicit meal.

The 'hovel' also housed my father's bicycle, again in pristine condition, his cycle clips hanging from the handle bars. There was also a huge

wooden block used for chopping firewood and splitting logs for the open coal fire.

Dad was a man who hated wasting anything and threw nothing away. Periodically, our mother would clear out drawers and cupboards, usually in the spring when the annual 'spring clean' took place, a hang over from the old days when spring heralded a new beginning. The things she threw out were nearly always salvaged by Dad who would remark "You never know when it might come in 'andy". These objects rescued from the rubbish heap invariably finished up in the 'hovel' hanging on the walls or neatly stacked on the shelves which contained, among the other discarded flotsam and jetsam, tins of nails and screws, saved 'just in case', the nails all neatly straightened out and graded into different lengths and sizes.

A man of infinite patience, he would sit for an hour or more unpicking the knots from a length of string, again 'just in case'. We children were never allowed to enter the hovel without Dad's specific permission or to fetch things for our mother. That was his domain. I can still smell that distinct odour, a mixture of pig meal, Karswoods Poultry Spice, bicycle oil and paraffin.

I will always remember my father as a just and honourable man, loyal and loving towards his family and a good provider. Not always easy to talk to, I think that he sometimes found it hard to express his feelings. How I wish that I had listened more closely to his wise advice, which, in the way of most children, I chose to ignore.

Why is it, I wonder, that we find it so hard to open our hearts until it is too late to tell our parents just what they mean to us?

Chapter Four

GOING UP IN THE WORLD

In the autumn of 1936 several major happenings occurred within our immediate family circle. Our fortunes had already changed for the better when, some time before, my father had obtained employment at the Harbury Cement Works as a packer. How well I remember the excitement engendered by the news of that humble appointment. I am sure that no high powered executive elevated to a prestigious place on a Board of Directors ever felt such jubilation as my father must have felt when imparting the wonderful news to his small family. A full-time job after more than three years being unemployed must have given him cause for much happiness. Not least, I can imagine, the joy of at last eliminating the necessity of that humiliating weekly bicycle ride to Southam Labour Exchange ending the indignity of standing in line with dozens of other unfortunates to 'sign on' making sure of that meagre amount of dole money. The original building, fronted by a small wooden balcony, still stands on the Leamington Road just before the turning to Market Hill and Southam High Street. I believe it is currently in use as professional offices.

There was now a little more money in the coffers, but there was also a down side to this turn of events. Before this my father was usually employed on casual farm or building work. When he was not working he would be busy on his allotment at Churchlands. Always working out of doors he looked tanned and healthy. Now he would return home each day covered from head to toe in a fine film of cement. Even his eyebrows and lips bore evidence of his labour. Today machines have been created, designed to lift, carry, fill and seal those bags of hot choking cement. In the days of such manual labour the work was physically hard and the associated health hazards were not to be recognised for many years. Those fine particles of lime penetrated everywhere – the blue enamel billycan that contained his mashing of tea and sugar and the square biscuit tin adorned with a picture of a thatched cottage and bearing the legend 'EAST, WEST, HOME'S BEST', that carried his sandwiches or 'snap' as he called it, were both ingrained with that grey powdery substance that clung so stubbornly to his skin and clothing. Even his bicycle, his pride and joy that he cleaned with loving care each week, did not escape and was constantly stained a dirty putty colour. Before entering the house he would remove his boots and outer garments giving them a firm shake to rid himself of as much of

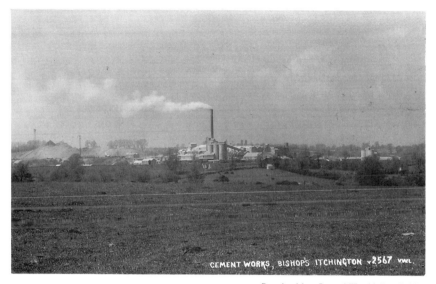

Cement Works at Bishops Ichington.
Slag heaps and overhead buckets just visible on left of photograph

that obnoxious dust as possible.

It was at this time that the weekly ritual of handing over my mother's housekeeping money began. A ritual that was to remain throughout the whole of his working life. It began as soon as he walked through the door after finishing work each Friday, pay day. First he would sit down and, opening his pay packet, would carefully check the contents against the enclosed pay slip. Satisfied that all was well, he would then slowly count out my mother's portion, several times, making sure that the amount was correct. Thus satisfied, he would firmly place it beneath the clock in the centre of the mantelpiece, after which he would replace the envelope in his back pocket buttoning it down firmly, then giving it a fond pat with his hand. He would then retrieve three bars of chocolate from his knapsack. Cadbury's Peppermint Cream or Turkish Delight for David and myself and Fruit and Nut for our mother. These he would place beside the clock. All this in complete silence. His duty done, he would then take his place at the head of the kitchen table and enquire "What's for tea Jessie?". We knew then that the ceremony was over and we would be free to speak'!

Yes, things were certainly 'looking up'. The icing on the cake must have been when we were allocated a new house – No. 13 Council Road – later renamed Pineham Avenue. Now, not only had we a father in permanent

employment, we had also reached the dizzy heights of actually contemplating the luxury of a bedroom each, electric light, and, wonder of wonders, a real BATHROOM; albeit the bath water had still to be heated in a brick copper requiring a fire to be lit underneath, but this was now situated at the end of the bath bearing an enormous brass tap that reached out over the bath threatening serious injury to anyone unwise enough to lean back during ablutions!

In the frenzy of modernising after the Second World War, these cast iron monstrosities on legs were unceremoniously ripped out by the dozen. It now seems ironic that they are considered prize possessions by people wishing to re-create such bathrooms in both the old authentic and pseudo-cottages and houses that are built today.

They also seek the ornate Victorian lavatory pans and wooden seats that suffered the same fate. Discarded in favour of the violently coloured 'suites' which included the ultimate 'in thing' of that period – the continental bidet. Thrown out at the same time were the cast iron fireplaces with their pretty surrounds of decorative tiles that were once so popular in our bedrooms and sitting-rooms and the black leaded kitchen ranges and cottage fireplaces.

Life for my brother and I changed overnight when we left behind the cloistered privacy of a small communal yard surrounded by loving, caring neighbours, where we only had competition from two other children and, therefore, received lots of attention. We now entered an entirely different environment. There must have been forty or more children living in the twenty four council houses in our own road and those in South Parade. All ages ranging from tots to teens. Both David and I remember a distinct sense of isolation when we were so rudely ejected from our safe little world. However, it wasn't long before we were all playing together and, along with our young mothers, made many friends. Some friendships were to last a lifetime.

There was the Padbury family, our second cousins, the Austins, the Birds, the Bishops, the Whites, the Bloxhams, the Sheasbys and the Savages, who also moved from Church Street to reside at No. 22. Families, many of whom still remain living in or around Harbury.

For a long time Council Road remained a dirt road, the Southam Council claiming that it was 'unadopted' and, therefore, not their responsibility. I recall a great deal of controversy before it eventually acquired a proper surface. Up to then it was covered with sand and builder's rubble that became a quagmire in wet weather, with the result that most people residing at the top end of the road preferred to use Pineham Lane to gain access. An open path ran alongside the perimeter of our garden from the lane to the road. This caused quite a few problems such as dogs and two legged

animals encroaching on my father's newly cultivated vegetable garden. However, the Council fencing was finally installed and the problem resolved.

My father soon created pleasant gardens. He laid down concrete paths and a small lawn at the back of house which became, over the years, our favourite place just to sit in the sun or eat meals out of doors in the summer. I well remember the day when he carefully smoothed the cement over the surface that, in his usual way, he had meticulously measured and prepared to provide a wide path from the front gate all along the side of the house, only to find that our dog, Pat, a crossbred black Collie, had walked along the full length leaving his paw prints for posterity. I wonder if they are still in evidence?

At the same time he built a small wooden shed in the garden from old pieces of timber using tin for the roof. I moved in with my toys even before it was completed. Eventually, he gave in and I was allowed to use it exclusively for playing in with my friends. What wonderful times we had. That small building became in turn a house, a hospital, a school, a shop and afforded us hours of pleasure.

My parents lived in this house for many happy years until, with age, deteriorating health forced them to move into more suitable accommodation.

We had only been in our new home a few weeks when my grandfather, Edmund Mann, was involved in a fatal accident on Treens Hill. He worked for the Great Western Railway and had been called out during the night by another employee, Arthur Ivens, of Vicarage Lane, to go 'Fogging'. He was on his way to the Fosse signal box opposite Middle Road when he was struck down by a car in the thick fog. He died in hospital the next day. He was a 'ganger' and during foggy weather he was required to walk down the line and clip into position 'shots' or small detonators which would emit a loud bang when the wheels of the train passed over them. A method that I understand is still used today, warning the train driver when unable to see the signals. One 'shot' or bang meant 'caution', two meant 'slow down' and three meant 'halt'.

A few weeks after this sad happening, my father's sister Evelyn died in childbirth, leaving behind a baby girl, Olive, who was brought up by my Grandmother Mann, and a small daughter, Ann, who was cared for by her paternal Grandmother Fox in Warwick. A short while after, my father's sister, Elsie, was to lose twin boys, Robert and Frank, who were fifteen months old. I still remember the sorrow and loss felt by all the family when these tragedies occurred in such close proximity.

The years leading up to the Second World War were happy years. My brother and I soon settled down in our new surroundings, although the

transition from our old life to the new involved various changes in routine. We were both attending the infants school, the old Wagstaffe School in Crown Street, now a private dwelling. This meant a long walk there and back twice a day. No school dinners then. Quite a trek for a four and a six year old.

We made friends, bickered and quarrelled, fell out then made up again as children do, shared our toys, swapped marbles and comics delighting in the antics of Tiger Tim and Bruin the Bear and others in the 'Rainbow'. I remember too how we would race home from school each day eager to read of the latest escapades of Rupert Bear in the Daily Express, the age-less bear who is still alive and kicking and must have brought pleasure to many, many children. With time our tastes changed and our favourite comics became the Beano and the Dandy when we would read with relish of the adventures of Desperate Dan, Dennis the Menace, Korky the Cat and Keyhole Kate.

The girls played two ball up against the wall, skipping games, hopscotch and house, making their own individual 'houses' separated by rows of stones in the wide, dry ditch at the side of the playing field and Pineham Lane. Fashioning sweeping brooms from bunches of leaves, creating fire-places from stones and sticks of wood, using empty tins and jars for pots and pans and tin lids for plates. There seemed no end to our ingenuity.

In summer the boys would collect birds' eggs, respecting the old country code, taking only one egg from each nest (now illegal). They swapped 'fag' cards, played cricket in the summer and football in the winter using any old makeshift wickets, goal posts, bats and ancient tennis balls and no self-respecting boy in those days would fail to carry in his pocket a 6d mouth organ purchased from Woolworths nestling alongside an illicit homemade catapult.

We would search out those tiny blue and white Violets hiding under the mossy bank alongside the entrance to Harbury House where the Sabin-Smith family lived – the family who had originally owned the land through which the railway cutting was made to accommodate the railway in 1848 when it was the deepest cutting by volume in Europe. Dug out by pick and shovel when the need for so many pubs was realised to slake the thirst of those hard working navvies. At this time the primitive dwellings known as 'The Huts' were built to house those people in charge of the project. These small cottages ran alongside the railway at the bottom of Childyke allot-ments down Mill Lane. They were still occupied by families well into the 1950s. The work on the railway cutting and bridges required a large la-bour force. Quite a few of the well known Harbury surnames of today originate from that period. There is nothing left of those old buildings now. Only a few fruit trees remain and some old fashioned cottage flowers and

shrubs which still bloom each year, bearing evidence of this link with the past and the people long gone who tended their gardens so lovingly.

Often we would take the old pram to go 'sticking', picking up sticks and pieces of wood from the fields and underneath the trees and hedgerows where they had fallen or where strong winds had blown them. The thin sticks we dried in the oven to use for lighting the fire, larger pieces of rotten bough or fencing were sawn into logs to burn on top of the fire and so eke out the coal. We never broke off branches or pulled wood from the hedgerows. This was an unwritten law. By the same token we never caused any damage and we were always careful to close all gates behind us.

At blackberrying time Walworth's fields was the venue where we picked huge amounts of those fat, juicy berries which covered the hedges in profusion. All seasons bore their own wealth of nature's bounty. The best field for mushrooming, now built over, was opposite Mr Dickens, our Headmaster's house, still called Carlisle Lodge where, at the end of the garden, stands a large walnut tree, excellent for scrumping which was recommended to be carried out only by the stealthy and fleet of foot!

From the stream known as Stockell Gall that ran past the old barn in the lower field at Walworth's we would harvest wonderful bunches of water cress, my mother's favourite sandwich filling and we never forgot to take home a quantity of dandelion leaves for Snowy our pet rabbit who lived in his own little hutch at the bottom of the garden. Alas, Snowy left home one dark night during the meat shortage in the war. He disappeared without trace and was clever enough to shut and bolt the door after himself! I think that quite a few pet rabbits met the same fate at that time – "Sold, I expect, to some 'Townie' 'oo wouldn't know the difference between a wild rabbit or a tame 'un" said my father at the time. His opinion of town dwellers with their mental image of country folk as collective straw chewing idiots was, to say the least, rather low. I have often heard him say "If you want to find a fool in the country you'll 'avter tek 'im with you" and would tell stories of country folk in the war selling eggs, home cured bacon and other ill-gotten foodstuffs on the Black Market at extortionate prices, always ending the tale with the comment " 'oo were the fools then – them as sold it or them as bought it?".

In the spring and summer there were wild flowers to be gathered. We would pick great bunches including my all time favourite 'Keck' or Cow Parsley. Bearing those dozens of tiny florets joining up to form one perfectly shaped flowerhead, as in the Elderflower the natural ingredient for a perfect wine. Bluebells, Cowslips, Oxeye, or as we called them 'Moon Daisies', Primroses and Honeysuckle. My mother was very tolerant and would receive my floral offerings with what then appeared to be great enthusiasm, filling all available vases and jugs. These were often so numer-

ous that they would overflow onto the wooden lid of our soft water butt and were relegated to various jam jars and Shiphams fish paste pots according to the size of the blooms. There were, however, certain species that she would never allow indoors, including 'May', the blossom of the Hawthorn, declaring that it would bring 'bad luck', a hang-over from our primeval past.

We roamed the fields and meadows that had formed a part of the village since time immemorial. Indeed, we played along the top of the bank in Lovers Lane without realising that we were walking in the steps of our ancestors who arrived there more than three thousand years before. An Iron Age tribe led by their woman chieftain Hereburgh, from whom the name Harbury derives, built the first fortified settlement on that very spot.

We wove Daisy chains to wear around our necks and took picnic meals to eat sitting among the sweet smelling grasses and wild flowers that grew in such abundance before the over-use of pesticides. So many of these, such as the lovely Wild Orchids almost disappeared along with the beautiful butterflies that we country children took so much for granted in those carefree days but are now once more flourishing in the nature reserves created by people who care.

On really hot days we would just lie on our backs listening to the drowsy hum of the bees and the click-click-click of the grasshoppers as they went about their business. What activity goes on all around us if we take the time to listen and we think that we are busy! Watching the clouds moving slowly along like pure white surf rolling on a blue, blue sea. Wondering at the perfection of nature has never ceased to enthral. I can remember that same feeling of awe the first time that I flew over a range of mountains, tips poking through the clouds giving the impression of large pebbles covered with clear, moving water. Little did I think then that in my lifetime man would walk on the moon or that it would be possible to fly to the other side of the world in a little over twenty hours.

I wonder if man has not already become too clever for his own good and has already overstepped the mark?

Later in the year there was the thrill of opening those bright green spiky cases containing a perfect mahogany coloured conker, another one of nature's fantastic works of art, which we would find as we walked ankle deep through a crackling multi-coloured carpet of autumn leaves. Sometimes we found them underneath the trees down by the Three Arch Bridge next to Bull Ring Farm when the farmer, Harry Frost, would shout and chase us away, making the whole exercise far more exciting.

When the winter brought snow and ice we salvaged any suitable material we could find to make sledges. Old tin trays and pieces of wood confiscated from sheds and hovels of the right size and weight were put into

Sid Enefer the Blacksmith inside the old forge

use. We would troop en masse down to Treens or Temple Hill to try out our motley selection of home-made vehicles. Not for us the sophisticated gear of today. Who needed the Alps? We built wonderful snowmen, spending all day patting and moulding them into shape until our hands turned blue with cold resulting as often as not in a painful crop of chilblains on our fingers. Ah – but the finished result was well worth the agony when we stood back to admire our collective work of art. The finishing touches would be two shining eyes of coal, then someone would produce a tweed cap, someone else a pipe and another a scarf and gloves. All surreptitiously removed from our homes for the adornment of this regal gentleman. How sad we all felt when inevitably the sun came out, usually the next day, removing all traces of our frozen friend's existence.

We would work hard all day to make a long, gleaming, slippery, shining slide down the centre of Council Road, only to find that some spoilsport had crept out overnight and covered it with ashes. But we always had Park Lane Pit to slide on!

On those bitterly cold afternoons when our breath froze on the air, there were consolations such as toast, made by holding a thick slice of bread on the end of our old brass toasting fork in front of a glowing coal fire, next smothered with a thick layer of butter that melted and ran down the chin. Sometimes if we had had roast beef, there would be a basin of beef dripping with a thick layer of jelly underneath, lovely when sprinkled with salt! No toast, either made on a grill or in the most expensive toaster can ever come up to the standard of that home-made delicacy which we ate accompanied by delicious mugs of hot creamy cocoa made with milk.

Another favourite pastime was to watch Sid Enefer the blacksmith working at his ancient craft in the old forge on the corner of Chapel Street. I recently arrived back in Harbury just in time to see that piece of local history being demolished. What a pity that this old building could not have been preserved and utilised in some way for the benefit of the village. Say a museum or similar to house old photographs and other memorabilia of old Harbury of which I am sure abounds in plenty, tucked away in drawers, attics, sheds and barns.

Sid Enefer was a great character. He originated from Moreton Morrell where his father had a forge and from whom Sid had learned his trade. He arrived in Harbury in the early 1930s, a true craftsman, not only a farrier but a maker of fine wrought iron gates and railings as well as a repairer of farm implements.

We would stand gazing into the black cavernous interior listening to the tink-tink-tink of hammer on anvil as each unique piece of custom made footwear was eased into shape to fit the individual customer. Bellows fanned the flames and as the shoe was moved among the red hot coals held

by giant pincers sparks flew, the fire glowed red, yellow and orange, giving the whole scene the appearance of Danté's Inferno. Then came the sharp hiss, as the shoe was plunged into water to lower the temperature, followed by the acrid smell of iron on horn as the shoe was pressed into place. All this time the patient animal – pony, hunter or carthorse – would be standing quietly, held by the head by a groom or farm worker, waiting for the final act of nailing on the completed footwear.

It is not so long ago that these men in their leather aprons, gaiters and stout boots (there was always the possibility of an impatient customer) were one of the corner stones of the village, along with the miller and other now redundant members of the community who have, along with the thatcher, joined the ranks of 'lost arts' now ironically becoming 'specialised arts'.

On a more sombre note, I remember that sometimes as we left school in the afternoon we would hear a pig making that terrible screeching noise that they make when, for some inexplicable reason, they seem to sense their doom is close at hand and that the end is nigh. We would race along Chapel Street and stand in a row on the bank opposite the cemetery watching as the poor creature was manhandled onto a wooden bench, the bed of straw all ready underneath to burn off the bristles. Although the whole procedure filled us with horror, we seemed somehow compelled to remain, as if rooted to the spot, until the terrible deed was done.

Of course there were other diversions, such as scrumping apples and playing on the railway banks, standing as close as we dared whilst the old steam trains puffed their way under the Three Arch Bridge covering us with sooty smuts. Waving to the engine driver and his mate, who would be busy shovelling coal, and to the passengers who we envied so much for being lucky, and rich enough, to travel to 'who knew where'. Far away places perhaps such as London, Scotland or perhaps even the seaside.

Watching weddings at the church was another favourite for we girls. Although I must admit to a feeling of 'Oh, how I wish it were me' if a schoolmate, as of course often happened, was lucky enough to be a bridesmaid. I remember one such wedding when six bridesmaids, including one small bridesmaid who was the same age as myself, all carried bouquets of sweet peas and each dress emulated one of the flower colours. They looked wonderful and I remember to this day that terrible feeling of envy.

We were all brought up to respect authority, therefore our feelings upon meeting Mr Percy Clark, our village policeman, were mixed. He always seemed to be somewhere around riding his bicycle and even if we were not doing anything illegal, we always mentally sprang to attention whenever he appeared. He came to the village after serving in the Grenadier Guards in the 1930s. The policeman was then housed in Merivale House, South Pa-

rade, until the present police house was built further along. I remember two of us were riding a bicycle one day down Ivy Lane, one sitting upon the saddle the other pedalling, when we met Mr Clark. I nearly fell off the bike with fright. He didn't say a word, just looked at us. I crept around for weeks fearing that every knock on the door meant that someone had come to arrest me.

I cannot remember any vandalism or graffiti. We had very little pocket money but we were always occupied doing something or another. It wasn't all fun and games as we had our chores to carry out to earn our Saturday penny. By this time we had acquired a wireless set and once a week we were required to take the wet accumulator to be recharged. My father made us a wooden carrying box with a leather handle to carry it in. Mr Payne, the licensee of the New Inn, had a shed at the rear of the pub, now called the 'Gamecock' in Chapel Street, and it was there that he carried out this service.

Most Saturday mornings we took a large cake to be baked at Bob Thornicroft's Bakery. There to be added to the varied collection of customers' cakes set out on the counter. All shapes, sizes and flavours. Each with its individual label of greaseproof paper stuck in the centre pencilled with the owner's name. We were charged according to size. If I remember correctly, the average price was about two pence. These we would collect in the afternoon after they were baked and cooled. I am ashamed to say that any large, juicy sultanas or cherries showing through the sugary crust on top would have disappeared by the time we arrived home. Likewise if we were sent to the Co-op for a pound of cheese, the small makeweight on top would suffer the same fate. I suppose today it would be legitimately called 'one of the perks of the job'!

Sometimes we would be sent to fetch corn and meal for our hens which were now well established in their own wooden hut, surrounded by a wired in run at the top of the garden. This we would wheel home from the Mill, purchased from the miller – Bert Haines – in our now defunct baby's pram. These hens provided us with a bounty of brown eggs with rich golden yolks. Vastly different from the anæmic looking thin shelled objects available in the shops today. Little wonder when one thinks of the poor creatures cooped up in their wire cages fed from a conveyer belt then unceremoniously despatched when no longer productive to be used in tinned dog and cat food or as fillings for pies. My mother refused in later life to buy eggs or a roasting bird which, as she phrased it "had not been allowed to run about". When we had an abundance of eggs the surplus was dropped into a large brown earthenware 'crock' in the back of the pantry containing a preservative called Isinglass. This formed a covering on the surface similar to very thin ice. How I hated putting in my hand when sent to fish out eggs for cooking.

Our Saturday penny, or more if we had been industrious enough to run an errand or two for a neighbour, was not spent in haste. Much deliberating went on before decisions were finally reached. We had a choice of several shops to honour with our custom. There was Mole's in Church Street, Messer's in the Bull Ring, the Co-op in High Street, and two little shops in Chapel Street – Bayliss's, a tiny shop in one of the front rooms of their cottage (old Mr Bayliss also pushed a little hand cart around the village selling fruit and vegetables), and Treens where the Hairdressing Salon is now. We nearly always opted for Messer's who had the best selection and we would stand peering in the shop window for a long time weighing up the pros and cons.

Five toffees cost one halfpenny, but for the same amount of money one could acquire quite a good sized bag of aniseed balls (which lasted longer). Kali Suckers, or sherbet dabs as they are now known, in a triangular bag with a toffee spoon to 'dip in' sticking out of one corner and a piece of liquorice to 'suck through' in another was excellent value at one penny, as when the Kali had all been eaten you were still left with the toffee spoon and liquorice. What a bonus! If you were very affluent and wanted to splurge your money, usually to impress your contemporaries, there were large Walnut Creams with a walnut embedded on the top to be had contained in their own individual brown and gold wrappers for two pence.

Our selection decided upon, we would enter the shop. There was a polished counter on either side, on the left was the sweet counter. At one end stood a pretty pair of Victorian brass scales, the weights standing in a graduated row looking like chess pieces. Although when inside the shop we often changed our minds several times before the ultimate purchase, we were encouraged to take our time. After all, we were the customers. Royalty, shopping in Harrod's, could not have been treated with more courtesy.

In the summer another delicacy that Messer's sold was homemade ice-cream. It was butter yellow in colour and the taste was quite unique. A taste like no other that I have ever eaten since. Ice-cream was also brought around the village in the summer by a man riding a three wheeler tricycle with an icebox contraption on the front. This was emblazoned with the logo 'Walls Ice-cream – Stop me and buy one'. We usually did. Our favourites were called Snow Fruits that came in various flavours. Long, three cornered sticks covered in a wrapping that looked like thin cardboard at a cost of one penny.

We also had our own 'Takeaway' – Bill and Rene Lowe's fish and chip shop, who started their business in 1931 from a little stone building in Ivy Lane. They later moved down to the bottom of Crown Street where their

shop stood alongside the Women's Institute hut. Long ago demolished, the site is now a car park for the Working Men's Club. Their fish and chips and potato scallops were delicious. There was only one snag. The 'chipper', a machine attached to the end of the counter, only 'chipped' one potato at a time, therefore, it was no use going there if you were in a hurry!

Derek Lowe, their son, still lives in Harbury and spoke to me recently of Mr Gascoine, his grandfather, who I remember. He lived in Church Terrace and was a first class tailor who worked from his 'hovel' which was his workshop in the back yard. He made servant's uniforms and hunting pink outfits for the local gentry, sometimes having to wait a long time for payment, perhaps with just a half-crown paid off here and there. He made the first bottle-green chauffeur's uniform in this area for the people at the Hall. Up to then they had always been black in colour. He maintained that when he sewed a button on it was sewn on for life.

By this time almost everyone had a wireless set reposing in the living room. Programmes such as 'In Town Tonight' on Saturday evenings when the sound of busy traffic could be heard building up, then a loud commanding voice would suddenly interrupt with the words "Stop – once again we stop the roar of London's traffic, to bring you *In Town Tonight*". Then, after a loud crescendo of music, famous or infamous visitors to London would be interviewed, although not such personal questions would be put as today and, believe it or not, we, the public, managed to survive without the sordid details of the umpteenth divorce pending or the latest live in lover! 'Happidrome', that mythical music hall that survived to delight us all each week, despite the loony ministrations of Mr Lovejoy, Ramsbottom and Enoch. 'Inspector Hornley' satisfactorily solved a different crime each week. 'The Man in Black' told his creepy stories that held us rigid in our armchairs waiting for the twist that always came at the end of each tale. 'Stanley Holloway' regaled us with his ditties imploring 'Sam to pick up his musket', that sad tale with a moral at the end called 'Brown Boots' and the awful saga of the demise of poor little Albert Ramsbottom in the lion's cage at the zoo. All good clean family entertainment. We children were allowed to stay up later on Saturday nights to join in the fun provided that we were all ready in our nightclothes to go straight up to bed at nine o'clock.

We had our own daily programme in the form of 'Children's Hour' hosted by 'Uncle Mac'. 'Toytown' with Mr Grouser, Larry the Lamb, Dennis the Dachshund and Ernest the Policeman was a firm favourite of ours. Along with 'Romany' the gypsy who would take us on walks through the country with his dog, Raq, describing the plant and animal life along the way allowing us to use our imagination.

As we played in the sun the early years of our childhood sped past. The

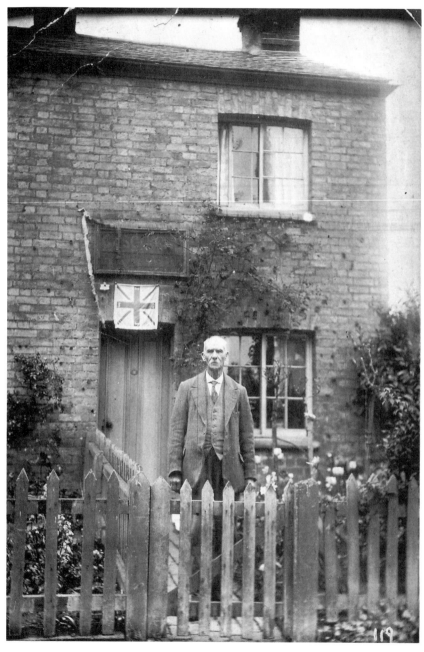

Mr Gascoigne, Tailor,
standing in front of his cottage in Church Terrace

clouds of war were gathering, although we were too young to realise the imminent danger.

The next few years were to bring many changes in our day-to-day lives. Changes that would have far reaching effects for so many of us and village life, as we knew it, would be gone forever.

Chapter Five

JESSIE MAY MANN (NÉE TAYLOR) 1911–1976

The first clear memory I have of my mother was when I was three years old and attending the Wagstaffe School. I knew that each afternoon I could leave the haven of the classroom safe in the knowledge that she would always be there, displaying that special bond of love that exists only between mother and child, waiting on the far side of the wooden gate at the bottom of the playground. There she would stand with my small brother in his pram a small, dark-haired figure, smiling and waving.

Often we would then go for a walk around the Bush Heath with me sitting on the end of the pram. Sometimes we called at my Uncle Jim Mann's thatched cottage in Farm Street to visit his wife, Auntie Elsie, and their small son, our cousin, also named David John. Auntie Elsie and my mother were great friends. They were always laughing and full of fun. They danced for us, dances such as 'The Black Bottom', and my mother would give her impression of 'Jessie Matthews' singing 'Dancing on the Ceiling' and 'Over My Shoulder', but the thing that I remember most of all about those visits was the fact that the old fashioned wooden lavatory seat contained not one hole but two. A big one for adults and a smaller one for children. Believe it or not, I read somewhere quite recently that they too have now been added to the rare collectors' items list!

My mother was born in Leamington Spa in 1911 and was for ten years to remain an only child. In 1921 her sister Beatrice Olive (known as Olive) arrived and in 1926 a brother Edgar Frank (known as Frank).

My grandfather was in the Army and until he was sent overseas in the First World War my mother and grandmother went with him wherever he was posted. One of the places where they were billeted for quite a time was Bacton-on-Sea, a small seaside village in Norfolk. My grandmother had a lovely china plate embellished with a painting of the house where they stayed. Years later I was able to take my mother back to the village with my own children where we spent several happy holidays.

My Great Grandmother and Grandfather Smith lived in Park Street, Leamington Spa, now the site of The Royal Priors Shopping Centre. Harry (or Henry) Smith was a stonemason. He worked on many of the historical cathedrals in England and finished his working days as a master mason at Warwick Castle. He always wore a bowler hat, the symbol of a craftsman, and I understand was quite an accomplished violinist. As a very small child

I can just remember Great Granny Smith spending a holiday at Bishops Itchington with her daughter, my Granny Taylor, and thinking what an old, old lady she was.

Our mother often talked about the happy times she spent as a child when visiting No. 35 Park Street. Her Aunt Caroline, Granny Taylor's sister, and her husband Uncle Harold Parish, lived at No. 7 along with their children, my mother's cousins. The company of other children was like heaven to her, an only child. She would tell of how, on Saturday nights, they would all go along to the Salvation Army citadel, also situated in Park Street, heartily singing, along with the rest of the congregation, those rousing hymns which she later sang to us as children. I strongly suspect that there may have been an ulterior motive behind all this enthusiasm in the form of the currant bun and cup of cocoa available at the end of the service!

Sometimes they went to the music hall, sitting high up in the gallery. Aunt Caroline was chief dresser and Uncle Harold the electrician. The 'Theatre Royal' in Regent Grove, Leamington, opened in 1882 and closed in 1934 to become the 'Regent Cinema', a favourite venue of mine in later years where my friends and I often enjoyed our Saturday afternoon film exploits.

In those days beer was often drunk at supper time, a meal always served about 9 o'clock in the evening, consisting of bread and cheese, cold meat and pickles. Mother would be sent to fetch the jug of draught beer from the 'Globe Inn' next door to her aunt's house, No. 7. Off she would go importantly carrying the big china jug, full to the brim on her return journey with the strong smelling, frothy ale.

When she was fourteen years of age she left school and took up a position of maid in the home of a 'Reverend' gentleman and his wife at Stratford-upon-Avon. The house was large and the only other servant was a cook named Mary. The lady of the house had a habit of creeping around silently, suddenly appearing at a door or outside a window which was, according to my mother, quite unnerving. She was also extremely frugal and rationed out so much food each day for Mary and Mother, usually food that had been left over from her own and her husband's meals the day before. Then, the pantry door would be locked.

Although the work was hard and the environment, to say the least, miserable, Mary and Mother seemed to turn every situation into a joke. She often told us 'the tale of the toothbrush', of how the mistress of the house instructed them always to turn the mattress daily on the large feather bed in the master bedroom. This they did. One day, during this operation, they found a small toothbrush under the mattress right in the centre of the bed. This happened each day for about a week and each day after the daily ritual

Great Granny Smith

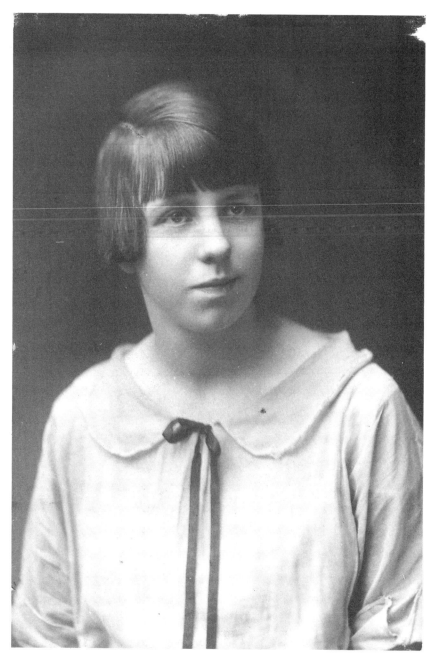

Mother aged sixteen

they replaced the brush as they had found it. Eventually the mistress sent a message for them both to see her in her sitting room. "Now," she began, "I thought that I gave you both strict instructions to turn my mattress every day. It is obvious to me that you are not doing so." "Oh but we are Mum," replied Mary "*and* we are putting the toothbrush back!" This tale was repeated to us often with much laughter and no hard feelings.

Shortly after this she went to 'Flaxhill House' at Ufton to work as a parlour maid for Captain and Mrs Horton. This was a very happy household, far different to the one that she had just left. There was a much larger staff too, which made life a lot easier. A cook who was a girl from Harbury called Kate Field, a general maid, Mother, the parlour maid, a nanny for the two children, a Nursemaid who was also from Harbury – Margaret Bloxham, and a gardener-chauffeur – George Bishop from Harbury. The staff ate the same food as the family. According to Mother it was top quality and in plentiful supply. No locked pantry either! For instance, the breakfast menu was always the same and laid out in buffet style on a long side table in the dining room. Silver dishes containing bacon, eggs and kidneys. Kedgeree, made with rice, flaked fish and eggs (Mother's favourite) and each week a fresh, whole ham was baked and served with a coating of bread crumbs. Any of this ham that remained uneaten at the end of the week was given to the cook to dispose of.

By this time Mother had invested in a second-hand bicycle and on her day off would ride home to Bishops Itchington with a bulging bag hanging from the handlebars containing her share of the bounty of 'left over' tasty food that Kate Field would have carefully packed up for her to give to my grandparents. On her weekend off she always cycled to a village dance at Bishops Itchington or Chesterton. It was at one of these events that she first met my father, whom she married at the age of nineteen.

She related many amusing incidents that happened during the early days of her married life. It seems impossible to imagine how little she knew then about the art of cooking when I think of the wonderful cakes, puddings and wholesome meals that she produced for us. Two of her favourite tales were connected with her lack of knowledge in this area.

Auntie Gladys, my father's youngest sister, my role model when I grew older, paid a visit one day to deliver two fresh herrings sent by Granny Mann for Father's tea. Carefully my mother coated them with flour and slowly cooked them in the frying pan until they were crisp and golden brown, just ready to serve with bread and butter when the man of the house arrived home from work. Proudly she placed them in front of him. He ate them with relish and as he wiped his mouth he casually asked "How did you get on removing the insides?". "What insides," she replied!

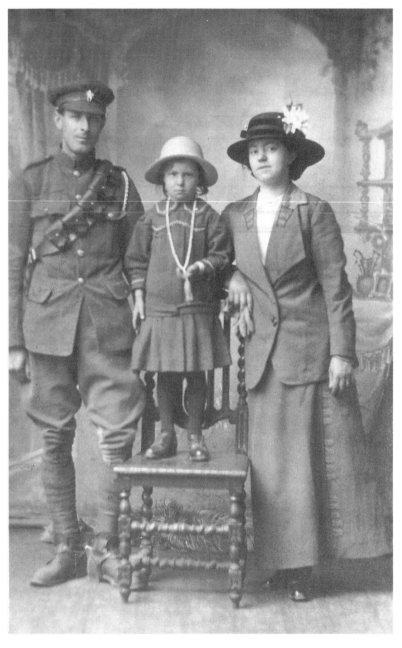

Granny and Grandfather Edgar Jessie Taylor and my Mother
taken during the 1914–1918 War

The other story was about the day that he presented her with a rabbit to cook for dinner. On his arrival home, looking forward to his rabbit stew, he found her in tears. She had been trying to cut off the rabbit's fur with a pair of scissors!

In those pre-video and TV days children entered the land of fantasy and make-believe through the pages of their favourite story books. My mother read to us every night. My favourite story was 'The Little Matchgirl'. I would wait in agony for her to reach the end and cry bitterly imagining the poor frozen little body lying in the snow.

Mother was one of the most disorganised people that you could possibly imagine. Hardly anything she did was pre-arranged but this had its compensations. During our summer holidays from school, on those mornings when the mist arose like liquid silver heralding another fine day, she would suddenly announce that we were going to visit Granny Taylor. We would set off early, walking across Walworths fields to Bishops Itchington, arriving in time to spend a day fishing with my mother's brother, only five years my senior, in the brook off the Ladbroke Road. We sat in the sun with our home-made fishing rods, a bamboo cane rod with a line of black cotton thread and a bent safety pin, catching sticklebacks and tiddlers on the banks of the brook overhung with willow trees resembling the bead curtains that people now hang over their open doors in summer.

Or we played in the spinney at the back of the cottages, in the shade of huge old trees, making make believe 'camps', cadging old sheets from Granny to make our tents. Behind the spinney was a large field known as 'the park'. I think it must have once belonged to the large house that I remember was situated further over at the top of the field next to some old cottages. We played with Granny's neighbour's children, Shelia French and Alan Holder and the Payne twins who lived at the bottom of the hill. Other children would sometimes join us. The girls would sit on a grassy bank knitting dolls' clothes whilst the boys played cricket after searching for suitable sticks of wood under the trees to improvise as stumps.

Often on a Sunday afternoon we walked from Harbury to Bishops Itchington taking the route along Beggars Lane into Plough Lane which was then a gated road. After tea Granny would usher us all down the hill to the village green opposite the church in plenty of time to settle comfortably on one of the wooden seats to await the arrival of the Bishops Itchington Silver Band under the direction of their conductor, Mr Dalton. Of course as far as Granny was concerned the main attraction was the trombone player, my young Uncle Frank who was the apple of her eye and if, by any chance, her favourite marching tune 'Under the Double Eagle' was included in the programme her happiness was complete.

Granny's old cottage in Station Road, along with the rest of the 'row',

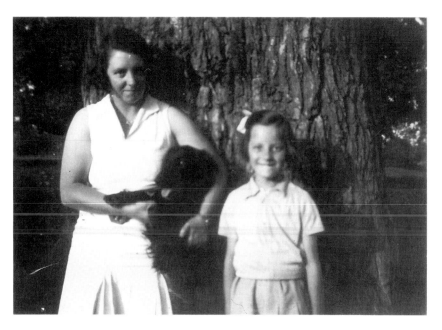

Mother, myself and dog Pat in the spinney at Granny's – 1936

has long since disappeared but the memories of those happy days live on in my heart.

Mother had a quick wit and could see the funny side of any serious situation. She had a great love of animals, hated housework and would seem completely oblivious to the piles of washing up waiting in the sink or the ironing piling up in the washing basket. Her philosophy was that life was for Living with a capital 'L'. The mundane things could wait. She was always late for everything. Her complete disregard for time was infuriating at times but, in retrospect, I now see that this was one of the endearing things about her. Some of the female members of the family have inherited many of these characteristics and are viewed as slightly eccentric but I see it as our mother's influence when we were children when she taught by example what life is really all about.

It is inevitable that along with the ageing process physical changes take place. Since the advance of scientific knowledge, logical explanations dotted with words such as 'chromosomes' and 'genes' have enlightened us all on the wonder of creation and the many physical and mental traits we may inherit. However, I never cease to wonder when today, looking in the mirror, I see the child within looking out upon a clear image of Jessie May.

Chapter Six
SERVICES RENDERED

The village shops, augmented by numerous vendors providing door to door services and villagers and professionals working from home offering specialist services, more than adequately supplied our day to day needs.

As well as a grocery section, the Co-op boasted a comprehensive drapery department, also a bakehouse situated in a separate building across the yard which backed on to Mill Lane. In another outhouse animal feed was stored, weighed out for sale in 7 or 14 lb bags on huge scales. At the end of the yard stood a storage tank containing paraffin which was sold by the gallon.

The baker, Harold Wilkins, was assisted by Harry Shaler and a succession of school leavers. One lad I remember was John Hopkins who later went on to become a roundsman delivering bread, groceries, pig and fowl meal, etc. in and around Moreton Morrell, Lighthorne, Ashorne and Chesterton, accompanied by Jack Bloxham. Jack started work for the Co-Op at 16 years of age and was employed there for over fifty years without a break, apart from his service in the RAF during the Second World War. I must mention in passing that he is no mean snooker player – he has been a member of Harbury Village Club for sixty-five years and still enjoys a game.

Although most of our basic requirements were catered for, anything not in stock such as larger items of furniture and household requisites, could be ordered from Northampton which was then the Head Office.

Coal was also delivered around the villages. I can still see in my mind's eye those rows of neatly stacked bags of coal and the large scales at the end of the open backed lorry on which each 1 cwt sack was checked by the coalman, either Fred Wells or Percy Weaver, who would then stand with his back to the side of the lorry and carefully hump the heavy bag of coal across his leather-clad shoulders. The coalyard was opposite the school. This was also where Mr John Honiwell, the manager, garaged his car, there being no garage attached to his house which stood next to the shop (now privately owned).

Mr and Mrs Honiwell came to Harbury from Duston in Northamptonshire. They both played a very active part in village life, especially in affairs of the church. Mr Honiwell was on various committees. He was a school manager and both he and his wife worked hard in a voluntary capacity. Mr

Honiwell was never afraid to leave the office, strip off his coat and don the appropriate working gear ready to take over any job in an emergency. He could often be seen delivering bread or coal and was always available to help out on a more personal level, from dressing up as Father Christmas at school parties to taking the elderly and infirm for hospital visits. They were true Christians who lived out their beliefs in their day to day life.

The little general shop in Church Street was owned and run by the 'Mole' family. Mr Mole was another gentleman who gave his services freely. Amongst other things he represented Harbury on the Southam Rural District Council, as it was then. It was mainly through his own and the joint efforts of Stan Smith's father who lived in Church Cottage and Mr Sparrow of Park View, Mill Street, that the children's playing field came into fruition, supported by money raising functions that took place around the village. Our mothers baked cakes to sell, and organised raffles and whist drives which were always popular in those days towards raising funds. We did not have the amenities that are available today, just the swings and a sandpit, but to us it was heaven, our very own place!

Mr Mole was also responsible for providing us with our first Village Hall. An ex-Army hut that he erected in Ivy Lane. This provided a venue for most large gatherings, including a travelling cinema van every week or so. How well I remember watching a film called 'Sweeney Todd, the De-

Interior of Harbury Church
showing carved rood screen removed some years ago

mon Barber', that anti-social hairdresser, who, after pulling a huge lever covered with a curtain to release the barber's chair, plunged his unsuspecting customer down into the depths of the cellar below. He would then descend the stone steps brandishing an open cut throat razor, and with bloodcurdling laughter and the comment 'I'll soon finish him off' proceeded to do just that! His next-door neighbour then turned the victims into meat pies to sell in her shop. This would have gone on if a sharp-eyed policeman had not discovered first a trouser button, then a human fingernail whilst eating his lunch – and we complain about violent videos!

It was quite usual for the projector to break down several times during the performances. This, along with the stoppages to allow the reel of film to be changed over, would result in shouts, catcalls and a violent stamping of feet, all adding to the evening's entertainment.

As well as the two sweet shops – 'Treens' and 'Bayliss' – there was a draper's shop (now Pete's Place) run by a Miss Henderson and Thornicroft's Bakery, all situated in Chapel Street. Mr Thornicroft and his son Bob delivered their bread in a little enclosed horse-drawn cart with double doors that opened at the back. Who can ever forget that mouth-watering smell of freshly baked bread on entering the tiny shop and those 'cottage' loaves, the ones with the small round ring on the top, presumably representing the roof, that when pulled off still warm from the oven and spread with plenty of butter and a thick wedge of cheese made a meal fit for the gods, especially if accompanied by a good dollop of home made chutney or pickled onions! Often we would be lucky enough to arrive there just as the iron doors were opened to allow the bread to be drawn out of the hot oven on the long 'peels' which were used to remove the loaves. They were made of wood, lozenge shaped on the end of a long wooden handle. Round the side of the bakehouse stood the wooden vee shaped vats on legs used to 'prove' the dough, and the sacks of flour. On the long wooden working top was a large set of scales on which each piece of dough was weighed after kneading before it was put into the baking tin.

At the bottom of Mill Street there was a small hardware shop at 'Westbury House' owned by Mr Harvey. Petrol (for those lucky enough to own a car) was available from hand pumps supplied by Miss Warwick at Brethren's Farm. The old tin 'Shell' adverts are still to be seen on the wall. Mrs Boynton ran a small shop from the front room of her cottage in Binswood End selling sweets, cigarettes and Brooke Bond tea.

There were three butchers' shops – Percy Cowley in Crown Street (Homestead) attended Rugby Market each Thursday where he bought his meat 'on the hoof'. Then there was William Bird and George Alcock. Their shops stood side by side in High Street opposite the Co-Op. George Alcock was a very tall man who always wore a tweed hat and carried an

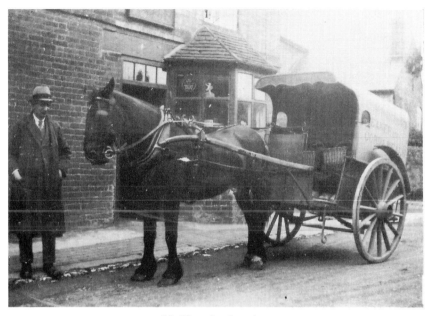

Mr Thornicroft senior,
outside the Old Bakehouse in Chapel Street

Interior of Thornicroft's Old Bakehouse, Chapel Street

extra long stick in his hand, a little like a shepherd's crook, called a thumb stick. He fattened up his lambs and other beasts in his field on Church Corner and a field that he rented at the back of Hall Lane. They all employed delivery boys on a Saturday morning who rode bicycles with large wicker baskets attached to the front.

The Post Office, run by Mrs Cooper, was in High Street which is now the newsagents. Our post was then delivered twice a day. Bertie Hillyard was our afternoon postman and would often greet us thus: Holding a postcard in his hand he would comment "Your sister is having a good time. The weather is fine and she hopes to be home on Saturday about six o'clock". He told me many years later that he also collected bets for the local bookie during his morning round at Chesterton. Quite a character was old Bert! In latter years, he was crippled up with arthritis which he attributed to working in all weathers as a boy on the farm.

On a Wednesday, a large open sided red van visited Harbury laden with every imaginable item of hardware. There were pots and pans, chamber pots, candles and candlesticks, glass chimneys, globes and wicks for paraffin lamps, small 'Kelly' lamps which were used in our bedrooms, brooms, buckets, blue bags, china and glass. This modern version of the latterday 'pedlar's cart' was driven by one 'Mr Rainbow' who was employed by Arthur Barr's, the hardware people in Clemens Street, Leamington. He also carried paraffin and methylated spirits. There was always a gaggle of laughing housewives around the van. I suppose those travelling salesmen with their gentle banter created a welcome diversion in the days when our mothers hardly ever left the village apart from the extra special shopping expedition into Leamington, perhaps twice a year. The family car, which we all take so much for granted these days, was decades away. In those days only the lucky ones owned a bicycle.

Colebrooks' brown fish van delivered fresh fish from their shop on The Parade in Leamington to the 'better-class' houses in the village. The shop with its distinctive smell and long marble counters piled high with all kinds of weird and wonderful looking fish arranged in their nests of ice held a particular fascination for me as a child.

Quite a few farmers delivered milk. Mr Rainbow from Pineham Farm came to us early in the morning. The pint and half pint measuring jugs with their brass handles were hooked over the side of the two heavy milk buckets balanced on the handlebars of his bike. My mother would go out into the street where he would measure the milk straight into the jug. Mrs Rainbow came round again in the evening with milk from the afternoon milking, hence we received fresh milk twice a day. I suppose this was necessary in the hot weather – no fridges! As we lay in bed we could hear Mr and Mrs Rainbow at 4 am in the morning calling Co-op-co-op-co-op as they

fetched the cows from the top field, which is now the football field.

In those days the old fashioned long horned cows were only moved out just before a match began and the evidence of 'cowpats' would be emblazoned all over the shirts and shorts of both teams by the end of the game. This was a problem from which we all suffered as children when playing in the fields. My mother was for ever grumbling about the state of our shorts and dresses and those bovine stains that proved so hard to remove. There were no commercial stain removers on the market then, just a bar of Sunlight soap and elbow grease!

Mr Wyatt from 'Whitegates' Farm took his milk around in a pony and trap. Billy Marlowe and Harry Frost from Bullring Farm also delivered by bicycle.

Mrs Spencer from Holland House saw to the ladies' and children's hairdressing requirements, working in her sitting room which contained in one corner a brightly coloured parrot in a large cage which was reputed to use the odd swear word now and again. On my regular visits for a 6d trim, much to my disappointment, I never heard him utter one word naughty or otherwise! Round the back of the house was a small shed where Mr Fisher, Mrs Spencer's father, mended shoes for a small fee. Stan Smith, who had a crippled leg, had his own little shoe repairer's hut in High Street, opposite the Co-op in between the two butcher's shops that I mentioned.

Frank Fletcher, who lived in one of the pretty stone cottages opposite the Post Office, where the supermarket and flats now stand, was the village barber, cutting the men's hair, again in his own home.

Toby Burton, one of three brothers who lived at Kingston House, 'doctored' all the tom cats. For this service he charged half a crown. As he handed back the outraged feline, spitting and struggling, furious at this onslaught on his most vulnerable parts, Toby would remark "There you are my lad. You won't get up to any tricks now. One nick and out they popped". Who needed a vet!

Teddy Blackford ran a little cycle repair shop from a room at the front of his house 'Ivy Cottage', which opened directly onto Ivy Lane and could always be seen working away whenever we passed by. I remember it cost 6d for a puncture repair.

There were other, more colourful vendors I remember – The Indian who would visit the village now and again wearing a bright turban, carrying his goods in a suitcase. He was very persistent and it was a strong householder indeed who did not submit to his non-stop sales talk. Although I do remember a neighbour of ours, who shall be nameless, after repeating several times that she did not wish to buy anything, exploding in complete exasperation and remarking loudly "If you do not go away I shall fetch the policeman" to which he replied "I do not worry about that lady.

Policeman better than you. He buy sock!"

Gypsies were often to be found camping around the outskirts of the village. One of their favourite places was Beggars Lane. This was then a narrow gated road, now extensively widened to accommodate the increase in traffic. This ancient highway has been in existence since man created the first dirt track as he travelled from settlement to settlement. The gypsies were vastly different from the 'New Age Travellers' and tinkers that abound today with their big cars pulling their gleaming mobile homes with all mod cons behind them.

These were the real Romanies, the genuine gypsies with their own language, customs and Queen. The gaily painted horse drawn caravans were spotless inside and out with shelves full of china plates and ornaments decorating the interior and bright paintwork on the outside. When they moved on, all that they left behind was a circle of ash where their fire had been. No rubbish. The men could be seen sitting on the caravan steps whittling away with a sharp knife, making long clothes pegs from willow and strips of tin which the womenfolk would bring around the village, their baskets of pegs, lace and other oddments for sale carried over their arms. They also made delicate flowers, always orange in colour, that looked like huge chrysanthemums. I think that they too were made out of some kind of wood. The ladies were always dark haired with very brown, wrinkled skin, especially the older ones who always persuaded my mother to have her hand read or her fortune told. These are the real gypsies who go back a long, long way in time, originating in the very beginning from India, eventually settling in Spain, then spreading across Europe.

We were lucky to have three resident doctors in the village. Dr Sutcliffe senior and son John, fondly known as 'Doctor Jack', ran their practice from Victoria House, Farm Street, where they lived. The surgery was a small room on the left that opened directly onto the road. Wooden seating ran around the walls and the consulting/examination room was up two stone steps. On one side of this area was the dispensary where cough medicine and ointments were mixed by the doctors themselves.

Dr Pirie's surgery was also situated at his home, Ashton House. He was responsible for researching and advocating fresh air and isolation for a disease that was then rife – TB – and set up a primitive treatment centre in a field at the back of Harbury Station where the patients were housed in wooden huts. He very rarely charged a fee when attending villagers but I do remember some kind of payment, about 4d a week I think, that my mother called the 'Doctors Club'.

The age of the 'washerwoman' was still with us and various housewives 'took in' washing and for a small fee would wash and iron a family wash.

Our village paths and roadsides were kept in an immaculate state by our

roadsweeper, Fred Hughes. Fred had a crippled leg but this didn't prevent him from carrying out his job. 'Slow but sure' was Fred's motto and he could always be found somewhere around the village with his little handcart, broom and shovel. How different the paths, kerbs and roadsides look today, for all the expensive 'sit on' equipment that must cost millions countrywide. Hedges were then cut and 'laid' not hacked and we all know that the roadside cutting machines have resulted in the loss of some of our most beautiful and, in some cases, unique wild flowers.

Many cottagers sold their excess vegetables for a few pence and bags of fallen apples and pears could always be purchased. One gentleman sold strawberries and regularly took the contents of his lavatory bucket along to his allotment on Pineham to spread over the strawberry bed. We would see him balancing it on the handlebars of his three wheeled tricycle as he passed the end of our garden. Needless to say, my mother purchased her strawberries elsewhere!

One of the more unusual services was carried out by an old gentleman who lived in the thatched cottage on the corner of Hall Lane and Crown Street. He would 'charm' away warts for sixpence. I know many people ridicule such stories and claim that it is all nonsense, but all I can say is that my brother had a mass of warts on his knees which mysteriously disappeared, as promised, a short time after the 'charming'.

The district nurse, Nurse Hartshorne, lived in the house next to the old Post Office and attended all home confinements and terminal patients.

When a death occurred there were certain women who would be available to 'lay out' the corpse which in those days remained at home until the funeral. All the neighbours would call to view the departed and to pay their last respects.

Many villagers still kept a pig or two in the sty at the bottom of the garden. Indeed, there are still to be found quite a few of those old brick pig sties, now usually housing garden tools and mowers. This meant that there was still a call for 'pig killers' such as Bert Morgan whom we would often meet on his way to carry out the grisly task, carrying his tools wrapped in his apron.

Those were the days of the coal fire and the services of the chimney sweep. Mr Watson of Church Street, was needed once a year, although quite a few people swept their own. The charge was about half a crown. All the furniture had to be removed elsewhere (outside if it was fine) and afterwards the walls and doors cleaned down. The soot seemed to penetrate everywhere, therefore, most housewives incorporated the visit of the chimney sweep along with the annual 'Spring Cleaning' and redecorating. A 'ball of whitening' could be purchased from the Co-op for sixpence to be used on ceilings and pantry walls.

Often a 'scissor grinder' would visit the village and would sharpen up knives, scissors, scythes, etc. on his foot operated grinding wheel.

The 'rag and bone' man would come with his horse and cart offering we children a balloon, or a goldfish in a jar that invariably died within a few days, for any old rags or scrap iron that we could persuade our mothers to hand over.

A weekly service that we all hated but could not do without, was the visit of the night soil cart. This was collected by Billy Marlowe in a foul smelling conveyance drawn by his faithful old Shire horse, Dolly. For some unknown reason this visit usually coincided with our evening meal time. We would be sitting down at the table just about to start to eat when my mother would leap up and down like a demented hen saying "Quick, quick, shut all the doors and windows. Billy Marlowe's on the way". The indescribable smell would reach the street long before the cart, warning us well in advance but nothing would prevent that all powerful odour from seeping through everywhere and remaining with us for a long time after the obnoxious vehicle had departed. I remember as a child feeling sorry for the horse!

Spiritual sustenance was provided by the Rev Albert Capps, vicar of the village church, All Saints, and various visiting preachers who attended the Wesleyan Methodist Chapel built in 1804, now a private dwelling. Flecknoe House stands on the site at the top of Dark Lane, presumably named after the family tomb that stood alongside the side entrance to the chapel.

I regret to say that our allegiance was apt to sway back and forth, from one religious denomination to the other depending upon which social functions were being organised at the time. We had these annual occasions mapped out to a fine art. So much so, that we rarely missed out on a single outing or party!

Chapter Seven
THE STORM BREAKS

"This morning the British Ambassador in Berlin handed the German Government a final note stating that, unless we heard from them by eleven o'clock that they were prepared at once to withdraw their troops from Poland, a state of war would exist between us. I have to tell you now that no such undertaking has been received, and that, consequently, this country is now at war with Germany."

So began Neville Chamberlain's broadcast to the nation on that bright, sunny Sunday morning at 11.15 am on September 3rd, 1939. The dark storm clouds of war that had been threatening had finally erupted. Although I was only eight years old, the details of that sombre moment remain forever etched in the darker recesses of my mind.

Groups of people were standing around on the lawn at Wissett Lodge. The atmosphere was tense as they conversed in hushed tones. The men looked grim and some of the women were crying. They were obviously waiting for some important and serious happening. Through the open French windows the wireless could be heard. A man began to speak. My father came over to join my mother, my brother and myself and stood quietly listening to the message that would change many villagers' lives and bring great sadness to so many families.

Mrs Farley crossed the lawn to speak to my parents. I remember her remark – "Well Frank, the balloon's gone up". I wondered what she meant. I couldn't see a balloon anywhere! We children were far too young to realise the serious implications of the situation. All we knew was that lots of exciting and odd things began to happen, in fact the village became a hive of activity.

Tom Manning, the village crier, circulated the whole area, ringing his bell, giving out instructions; telling us of things that must be done immediately, such as putting up thick 'blackout' curtains to all windows and glass doors, warning us that not a chink of light must show through after dusk. All street lights were extinguished and no outside lights were allowed. Headlamps on motor vehicles and bicycles were covered over to allow only a very dim glow.

The windows in public places, and a good many private houses, were criss-crossed with strong sticky brown paper. This was hoped, in the event of bomb blast during an air raid, to lessen the severity of injuries caused by flying glass.

Air raid sirens were tested. First the 'Warning' and then the 'All Clear' to acquaint us with what was soon to become an all too familiar sound. We were also told that the church bells would be rung nationwide to warn us of imminent invasion.

We soon became used to the absence of exterior lights and wore white armbands and patches on our outer clothing which showed up when we were out in the unlit streets at night-time.

We were issued with gas masks and were taught how to wear them in the event of a gas attack, and to identify the warning 'rattle' which would be sounded during an attack by the ARP Wardens. I remember that we were taken from school through a mobile 'testing' van wearing our masks, causing great excitement. Babies were issued with a kind of container into which they were almost completely immersed, with a hand-operated gadget on one side through which air could be pumped. Young children had funny ones that looked like blue and red Mickey Mouse masks, similar to those that are seen today in Disney World.

We older children and grown-ups wore gas masks which fitted closely around our face, kept in place by straps around the back of the head. There was an oblong perspex window for our eyes which misted up almost at once. I can still remember the smell of rubber and the horrible feeling of claustrophobia. We were meant to carry them with us at all times and spot checks were made at school to make sure that we had them with us. They were issued to us in a cardboard box threaded with string for wearing over the shoulder. Some of our mothers made us stronger, weatherproof carrying cases. The more fashion minded covered these with pretty materials for the girls, made to resemble smart handbags. Some were embroidered with our initials. One girl, who was the envy of our class, owned the most elaborate one of all, with her complete name and address worked in cross stitch surrounded with intricately worked patterns, flowers and birds looking like a miniature Victorian sampler. Even the short carrying handle was worked in the same manner. It must have taken hours of work and patience to complete. That such a beautiful work of art could be created to cover such a monstrous object with all the attendant implications showed, I think, in a small way the courage and determination of the British people at that time.

There was no shortage of volunteers for the local auxiliary forces required for our defence in the event of the expected 'invasion'. Villagers that we had known all of our short lives suddenly began to appear wearing a variety of uniforms. Among them were the ARP (Air Raid Wardens), men and women whose 'post' was in a building in High Street belonging to the Co-op. Much later it was to become a butcher's shop. The house called 'Butchers Barn' now stands on the site. The original building had big dou-

ble doors that were set back a little. Older Harbury residents will remember that convenient, cosy alcove was used for many years as a makeshift bus shelter.

The St John's Ambulance Brigade (later re-named the 'Rescue Service') under the command of Doctor Pirie had their headquarters at Harbury Hall and Mr Robinson's station wagon became the ambulance.

On May 14th, 1940, Antony Eden broadcast an appeal for volunteers for the LDV – Local Defence Volunteers. Twenty-four hours later 250,000 men had enlisted. The official name became 'The Home Guard' on July 23rd, 1940. Our very own 'Dad's Army' was recruited under the command of a very able 'Mr Mainwaring' in the form of John Honniwell, the Co-op manager, assisted by his equally able NCOs – Hughie Sheasby and Doug Gascoine, with Eric Warner as their despatch rider. Other ranks included Harry Frost, Chalky White, Percy Cowley, Frank Bayliss, Corrie Freeman, Ralph Gurden, Ted Ferguson, Norman Carter, Frank Fletcher and Jim Davies.

Compulsory military service had been declared on September 2nd, the day before the Prime Minister's speech announcing our official entry into the struggle for freedom. It was soon broadcast on our own village grapevine as each one of our young men and women were 'called up' or volunteered for the armed forces. The word would go around "young so and so's 'ad 'is papers then. I expect our so and so 'ull be next". Those village lads who were on the Army reserve list, having served in the Regular Army, and those from the Territorial Army were, of course, the first to join their units.

Village girls too joined the 'Forces' and appeared looking trim in their smart new uniforms. My aunt, Ethel Mann, was in the WAAF, Anne Farley and Peggy Tanner (whose two brothers were in the Royal Navy) chose the WRENS.

Women were drafted into diverse areas of 'war work'. Girls who had previously been engaged in domestic, office and shop work suddenly found themselves despatched to different parts of the country, some working in factories, producing munitions, tanks, planes, guns – the paraphernalia of war so desperately needed for our defence.

The girls of the newly formed 'Land Army' soon became a familiar sight around the village in their workman-like bib and brace overalls. When 'off duty' they changed into a smart walking out uniform of khaki breeches, green pullover and round pork-pie hat, which they wore with great aplomb.

Some of them came from towns and cities but they quickly learned to drive the tractors, milk the cows, work in the fields and generally took over the work previously done by the young men who were conscripted into the armed forces. Some of them married farmers' sons and remained in the

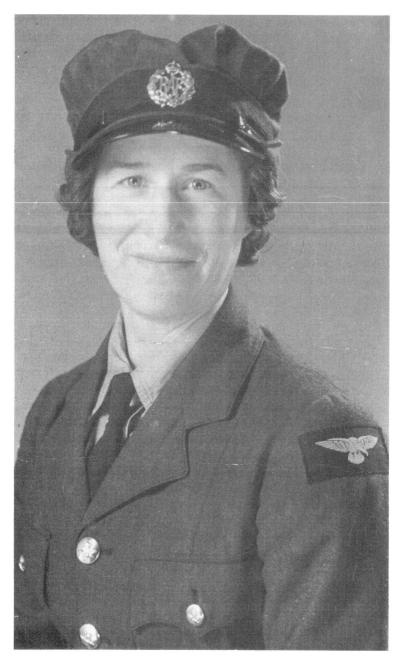

Aunt Ethel Mann in W.A.A.F. during the war

Land Girl – Polly Parker

village after the war. Polly Parker, who is a well known Harbury resident, was one example.

Needless to say, these girls were very popular with the village children. We loved to help with the farm animals and would cadge rides on the trailers pulled behind the tractors. I remember one land girl at Bishops Itchington delivered milk with a pony and trap. My greatest delight when staying with my grandmother was getting up at crack of dawn just to accompany her on her rounds.

Volunteers were called for to work down the coal mines. These men were nicknamed 'Bevan Boys' after Mr Ernest Bevan who was then Minister for Labour. Later on, however, when the shortage of coal became more acute and more and more was needed to aid the war effort, men were conscripted into the mines. I think Cecil Bloxham was the only man from the village who was called up for this work.

Meanwhile, waste paper, bones for making glue, old iron and other metals were collected for scrap to be melted down and used for building planes and other machines required for the war effort. Miles of wrought iron railings and ornamental gates were pulled up to be melted down for guns as well as domestic aluminium pots and pans to be used for building planes. Victorian mangles and other antiques that had been forgotten, stored away in attics, barns and sheds, were ruthlessly sacrificed on the altar of war.

The young Princess Elizabeth broadcast to the children of Great Britain. We were thrilled and each one of us took it as a personal message.

In May 1940 the Prime Minister and Leader of the Labour Party, Neville Chamberlain, resigned and was succeeded by Winston Churchill, who also became Minister of Defence with additional authority as the head of a special defence committee consisting of himself and Chiefs of Staff, the task of which was to make the day by day and, if necessary, hour by hour strategic decisions. A new coalition Government was formed.

In the first of what was to become a series of famous speeches throughout the war, Churchill told the members of the new Government "I have nothing to offer but blood, toil, tears and sweat".

Party preferences were forgotten and 'Winnie', as he became known, was soon recognised as having those qualities needed to lead the British nation through to victory in those desperate times. With his unique 'V' for victory sign, striped suit, homburg hat and fat cigar he became a symbol of hope and strength and was characterised as the famous 'British Bulldog'. There is no doubt that his words gave his fellow countrymen courage and the will to succeed in that terrible time of doubt and anxiety.

Later on General Bernard Montgomery also became a national hero as

he pitted his wits against his wily adversary, the German general – Erwin Rommel (nicknamed 'The Fox').

'Tink' Washbrooke of Harbury joined the Royal Warwickshire Regiment in the 1920s and for a time became Montgomery's batman when he was just a major. Tink remembers 'Monty', as he became known, as an exemplary soldier, professional to the extreme, expecting nothing less from his men. In return he carried out his duties as an officer in a fair and just manner.

It became fashionable to name pets after these distinguished gentlemen. Cats and dogs of all shapes and sizes answered to the name of Monty or Winnie, including Monty our own canary, who sang so beautifully until that awful day when he suffered a quick and untimely end at the hands (or paws) of our cat 'Tut'. Escaping from his cage during the weekly 'cleaning out' operation, it was all over in a flash when Tut leaped out from behind the sofa where he had spent many patient hours lying flat on his stomach awaiting such an opportunity.

From September 1939 and continuing throughout the war the infamous Englishman, William Joyce, dubbed 'Lord Haw Haw' by his British audience, broadcast each evening to his fellow countrymen from Germany. These messages of gloom and propaganda were designed to lower British morale. In 1944 Joyce was tried and executed as a traitor.

The situation was desperate but Hitler had underestimated the British fighting spirit that remains dormant until threatened. Social and political barriers were swept aside. As a nation, we British are rather a lazy, apathetic lot, but let anyone threaten our freedom, then we show our true colours, prepared to fight together to the death if needs be to protect this small island of ours. I believe it was a Roman general who, over two thousand years ago, described us thus: "They are fierce little men and courageous fighters in the defence of their land."

If any proof was needed, the combined efforts of the British people, Army, Navy, Air Force and civilians, and those little ships that went out to evacuate the thousands of troops stranded on the beaches of Dunkirk as the Germans advanced through France, illustrated that wonderful spirit. The strong feeling of togetherness that was to last throughout the war.

Operation 'Dynamo' was the code name given for the evacuation of as many troops from Dunkirk as possible. The order went out on May 26th, 1940, for the operation to commence. The German Airforce struck with all its might to try to prevent the evacuation and the pilots of British Fighter Command were sent in to attempt to keep the skies above the beaches clear enough to allow the evacuation of as many troops as possible. In the seven days of the operation, one hundred and seventy six German aircraft were shot down, with a loss of one hundred and six British aircraft.

The beaches were crowded with troops, lined up waiting to be taken off. Hundreds of craft from ports and seaside towns in the South of England, pleasure craft, trawlers, coasters, tug-boats, open boats, ship's lifeboats, river cruisers, paddle steamers, fishing vessels and more than six hundred small pleasure craft which between them brought off more than eighty thousand men in groups of from four to one hundred. Meanwhile, our troops were engaged in fierce fighting, fighting rearguard actions around the whole of the Dunkirk perimeter and others were besieged in Calais.

On May 28th, 1940, at the village of Wormhout, only seventeen miles from Dunkirk, men of the Royal Warwickshire Regiment, who had been stubbornly resisting the efforts of the SS Leibstandarte Regiment, their ammunition gone, were forced to surrender. They were ordered into the back of a barn into which the Germans threw grenades. Other guards opened fire all around the barn with machine guns. Five British soldiers managed to escape. Forty-five of their comrades, 'prisoners of war', had been killed. Later that day, also at Wormhout, a further thirty-five Prisoners of War were murdered after their capture.

The day before, on May 27th, in a farmhouse near the village of Paradis, ninety-nine men of the Royal Norfolk Regiment had been engaged in savage fighting with units of the notorious SS Death's Head Division. Their ammunition exhausted, they too surrendered, only to suffer the same fate. Out of the ninety-nine, only two survived. Managing to crawl away, severely wounded, they were tended by a local farmer's wife. After the war, one of the survivors gave evidence and the German officer who gave the order to shoot was executed.

At midnight on June 2nd the last three thousand men, British and French troops, were taken off the beach at Dunkirk, bringing the total number of men to three hundred and thirty-eight thousand, two hundred and twenty-six in seven days. Thirty-four thousand were left behind and were taken prisoner.

The British retreated to lick their wounds and to take stock of the situation. The land all around the coast was ordered to be ploughed up and obstacles were planted on shore as well as in the sea, all in preparation for the expected 'invasion'.

On June 22nd, 1940, Hitler was present at Compiègne, the venue he had deliberately chosen, to take place in the same railway carriage where the Germans had signed the surrender at the end of the First World War. The armistice was signed. France joined Poland, Norway, Denmark, Holland and Belgium and would remain under the jackboot for four and a half years.

Winston Churchill told the nation: "The battle of France is over. The Battle for Britain is about to begin." The frantic preparations for defence

continued throughout Great Britain. Anderson air-raid shelters, named after the Home Secretary, Sir John Anderson, were erected in thousands of gardens, saving a great many lives when the terrible Blitzes began.

Waves of German bombers dropped tons of bombs upon our major cities as the Luftwaffe tried to bomb us into submission. I can remember our family standing outside in the garden listening to the drone of the German bombers overhead and watching the skyline lit up with a vivid orange glow, resembling an evening sunset. I remember being told by my mother "That is Coventry, burning". I remember visiting relatives in Coventry who had been 'bombed out'. Only the stairs of their house were standing, under which they had been sheltering. The streets all around were flattened heaps of rubble.

Much has been written about the 'Battle of Britain' that was fought in the air over London and the Home Counties during August/September 1940. We who can remember recognise that the eulogy spoken by Winston Churchill at that time is one of the truest statements every made. These were the words that echoed the feeling of the British people during that terrible ordeal: "Never in the field of human conflict has so much been owed by so many to so few."

It was then that Herr Hitler made his first big mistake. He called a meeting with his generals and, against their advice, decided to turn eastward. He made the following statement: "I will begin the final settlement of scores with the Bolsheviks." He was confident that he could bomb us into submission.

The word 'invasion' was still on everyone's lips.

Then came some exciting news. We were told to prepare for a minor invasion of our own village.

Chapter Eight
A MINOR INVASION

The day began like any other Sunday morning at Granny's house in Bishops Itchington, where I had been spending part of my school holidays.

The morning sun came streaming in through the window, filling the small bedroom with a bright golden light, reflecting the dainty fern pattern of the lace curtains onto the opposite wall where they danced, intermingling with the pretty clusters of pink rosebuds printed on the wallpaper. The window reached almost down to the floor and, as I lay in bed, I could see in the distance the rolling green hills of Burton-Dassett topped with an ancient stone lookout tower built by Edward Belknap at the end of the 15th century and the remains of an old wooden postmill, blown down in a storm on 26th July 1946, possibly the original mill built in 1664 restored in 1933/34 long since vanished. I snuggled down, cocooned in the big feather bed which, of necessity, was turned and pummelled into shape each day. How I loved that bed which I shared with Granny on my frequent visits.

I could hear the sound of breakfast preparations going on below. The tantalising smell of sizzling bacon being cooked on the open coal fire wafted up the narrow winding stair. I wondered if Gramp had found any of the tasty fat field mushrooms that he sometimes brought home, carrying them carefully in his cap. If so, they would be served piled high on crispy fried bread alongside the bacon, yellow topped eggs and fried potato saved from dinner the day before. Or, perhaps, as it was the last day of my visit there would be a duck egg boiled in its beautiful blue/green shell especially for me. In my mind's eye I could see Granny cutting off thick slices of crusty bread then spreading on the creamy yellow farm butter with the old bone handled knife that she always used. Which homemade jam would be on the table this morning I wondered? Tangy Plum, Marrow and Ginger, Blackberry and Apple or my very own favourite Strawberry and Gooseberry.

I could hear the gentle murmur of my grandparents' voices as Granny presided over the heavy black frying pan. The plates would be warming alongside a gently steaming kettle all ready to make the tea in the large brown teapot. Gramp would be sitting relaxed in his wooden high backed chair, puffing contentedly at a pipe of Thin Twist, his favourite tobacco. I lay, mouth watering in anticipation, wrapped in that childhood blanket of

secure contentment felt only when surrounded by people we love, safe in the knowledge that they return that love.

If I screwed up my eyes very tightly and then slowly opened them, I could see the silver dust motes falling through the air like so many minute shooting stars over the foot of the high brass bedstead. There was a loose bed knob on one side which gave the whole thing rather a lopsided effect when viewed from my deep nest of feathers.

The bedroom walls were adorned with several large gilt framed pictures. My two favourites depicted a rather anæmic looking your lady with long curly hair tied back with a satin ribbon.

In the first picture she was obviously at the point of death lying in a darkened room on a silken covered bed. Her faithful dog sat by her side wearing a mournful look, with its nose gently resting on the girl's outstretched hand.

In the second picture she had obviously made a miraculous recovery and was seen recuperating sitting in a pale green velvet chair, her dainty feet placed on a matching footstool, complete with faithful hound by her side (still looking mournful). The bedroom shown in the pictures was to me the epitome of luxury. Enormous full length windows with velvet drapes now drawn back to reveal a wonderful garden. Stone steps led down to perfectly manicured lawns, bordered by beds massed high with a colourful patchwork of flowers. Roses climbed over trellised arches and a perfect weed-free path swept down towards a distant lake where a small boat lay moored to a wooden landing stage. Inside, the room was filled with elegant furnishings. The green velvet chair and a matching sofa were arranged in the centre. In one corner stood the silken draped bed, rich with embroidered hangings. Small occasional tables were dotted around tastefully displaying tiny framed miniature paintings, small china ornaments, photographs and vases of flowers.

In my imagination I would enter that room, walking across the soft carpet, then out through one of the vast windows, which obligingly stood open. I would stand on the terrace amongst the huge stone jardiniers running over with geraniums of every hue and gaze upon that fantastic garden.

When I tired of this game of make-believe, there were other diversions.

In one corner of the bedroom stood the old marble topped washstand containing a pretty cornflower patterned china wash basin, jug and soap dish that had been given to Granny's mother as a wedding present. The shelf below held the matching chamber pot.

In the opposite corner, on bow shaped legs, was Granny's elegant dressing table. A work of art, the cherry coloured wood polished until it shone, resembling the bright gleaming conkers that we collected in the autumn.

On the top shelf stood a glass scent bottle, flanked on either side by a pair of glass ornaments shaped like miniature chandeliers. The faceted pear shaped crystal pendants tinkled in the faint breeze from the open window, each one sending a cascade of tiny shimmering rainbows across the ceiling. On the lower shelf were several pretty boxes. One was covered in purple silk, worked with an intricate pattern of pearls and beads and contained Granny's brooches, beads and earrings. My particular favourite was inlaid with mother of pearl and held her handkerchiefs, one of which was never used. It had been worked by hand by my mother when she was about nine years old. Made of linen with fine drawn threadwork and beautifully embroidered corners, the whole edged with crochet resembling a row of minute sea shells.

The little drawers below the shelves I knew held Granny's other treasures, such as the silk postcards that my grandfather had sent to her from France in the First World War, embroidered with flowers and loving messages. As a special treat, sometimes I was allowed to take them out of the blue tissue paper in which they were wrapped, look at them and then carefully replace them in their wrappings. My day dreaming was suddenly interrupted by Granny's voice calling up the stairs telling me to hurry and get dressed, reminding me that later on we were to walk to Harbury Station to meet my parents.

Silk card sent from France to my Grandmother by Grandfather
in the 1914–1918 War

The station lay conveniently between Harbury and Bishops Itchington, where my grandparents lived. This was the usual arrangement when I returned home after a holiday with Granny. But today would be different. Today we would be leaving much earlier to arrive in time to meet the special train that would be carrying children, their teachers and, in some cases, their mothers too, from London away from the increasing danger of air raids, a nightmare that some of them had already experienced. This was also the day that a new word was to enter our vocabulary. A word that as the war progressed we would come to know very well. The word was – EVACUEE.

We children had been well primed for the event by our teachers and the vicar when he visited the village school to take us for our Scripture lesson, but even if these illustrious persons had not imparted full details, we could hardly not have been aware of the important happening for had it not been the talk of the village for weeks? In the pubs, the Working Men's Club, the village shops, the Co-operative stores, the Post Office, Stan Smith's boot mender's hut, not to mention Mrs Spencer's house, where most of the females in the village attended for their hairdressing needs. ("Tell her to cut it to the tips of your ears, no shorter"), my mother would instruct me as she carefully handed over sixpence which was the basic charge in those days). In fact, anywhere that a group of more than two people was gathered together it was almost certain that eventually the main topic of conversation would be this important forthcoming event.

The Clerk of the Council, Mr Walter Owen, had accepted the wartime role of 'Billeting Officer' and in his official capacity had visited each house and cottage in the village and surrounding areas making copious notes on equally copious official forms. Namely number of people residing in each dwelling – sex of same – number of children, teachers or mothers that could be accommodated – preference for boys or girls – and any other relevant information.

We were ready to welcome these refugees fleeing from the danger of the London Blitz. Indeed it seemed that half the village had turned out to greet them, lining both sides of the entrance leading to the station yard, spilling over into the road.

The hierarchy, according to the village pecking order (the old feudal system to a certain extent in those days still remained with us) had formed a reception committee and was waiting on the platform. We waited with the rest of the lower order on the fringes of the crowd. Prams and pushchairs containing grizzling infants were used to secure a good vantage point and good natured banter was tossed back and forth through the crowd. Suddenly, the excitement grew as the signal went down and the train was heard approaching in the distance. Necks were craned forward

The Old Cobbler's Shop in High Street.
Left to right: Harry Haynes, Stan Smith and Les Overton

and the feeling of excitement increased. The train puffed into the station pulling up with a squeal of brakes and a loud clanking of wheels where it belched out huge clouds of thick black smoke, completely enveloping the front row of the official party, much to our childish delight, and began to disgorge what seemed to be dozens of children of all shapes and sizes, carrying their few belongings in small cases, carrier bags and paper parcels. They each wore a brown cardboard box containing a gas mask slung across their shoulders and a large label stating their name and age was pinned to

their clothing. Some of the tiny ones were crying, hugging a soft toy or clinging to an older brother or sister. Others stood around in obvious family groups. All looked confused and tired. They still had a long uphill walk into the village then on to the school where they were to be allocated to their new homes.

We entered the village, resembling for all the world a latter day 'Tribe of Israel' fleeing Pharaoh's hordes. An old man, who had been standing on the side of the road, wearing a look of complete amazement on his face, approached our mother and asked "What's a gooin on then?". She explained. "That's orl right then," he replied, "I thought for a bit old Jerry had started the bloody invasion". This must have been one area that the village grapevine had failed to reach!

Our mother had agreed to take two children and had specified 'girls', Somehow or another, by the end of the day, we found that our family had increased by three, all boys. Much to my disgust I was now outnumbered four to one!

Willie and six year old Georgie, who were brothers, soon settled down, becoming firm friends with my brother and I but it soon became apparent that the third boy, Ronnie, was terribly unhappy. He was very homesick and was worrying about his father who was in the RAF. His mother came to visit him and his sister Pamela, who had been placed with another family, and decided to take them both back to London. To separate brothers and sisters under these circumstances was unwise and must have caused a sensitive child such as he much unnecessary heartache and many sleepless nights. After all, most of them had already experienced at that early age, more emotional trauma than most people have to cope with in a life time. Our family was reduced by one. However, not for long, as the following year our mother presented us with a beautiful baby sister, which helped to even up the score!

Eventually we acquired another evacuee, Graham, an auburn haired bundle of mischief, who was always getting into one scrape or another. I remember only too well the day that he decided to light the primus stove to boil water for a cup of tea. The mind boggles when I think what might have happened if our mother had not arrived home just as the kitchen curtains were well alight.

I also remember that he had a habit of rolling Karswoods Poultry Spice into newspaper out of which he made his own supply of unique cigarettes! Graham stayed with us for a long time and continued to maintain contact with my parents throughout their life-time. On my last visit home I spoke to him on the telephone. He spoke of my mother with great affection and recalled the kindness she showed him during those wartime years, which he rates as one of the happiest periods in his life. A fitting epitaph to a very

understanding and compassionate lady. He still keeps in contact with my brother and loves to revisit some of our old haunts, such as the Three Arch Railway Bridge which the boys would daringly cross, arms outstretched, walking along the parapet. This was also one of our favourite spots for gathering conkers, the fruit of a splendid horse chestnut tree sited on the edge of Bull Ring farmyard.

At first we looked upon these sophisticated arrivals with great reverence. After all, they were from London – a city so far away that none of us had ever been there. We felt sure that they would all know the King and Queen personally. Perhaps even the Princesses Elizabeth and Margaret Rose. They spoke another language. We found it hard to understand their quick cockney accent. So different from our slow country dialect, they could have been aliens from another planet. It never occurred to us that we must have appeared equally as foreign to them, using everyday words and phrases that had changed very little since Chaucer's time. We found out, to our utter amazement, that most of them had never seen a cow, a sheep or a horse. Had never seen vegetables growing in a garden or fruit hanging on the trees. They had never roamed around fields and lanes gathering nature's bounty of crab apples, wild damsons, blackberries and nuts, according to the seasons. Had never gone around in a gang scrumping apples and pears and (if you knew where to find them) walnuts. Just for the devil of it all, sometimes we would pay an illegal visit to Dad's allotment down Childyke in Mill Lane pulling up tiny carrots, wiping them clean on a tuft of grass, before savouring their crisp, sweet taste and picking fat green pods of garden peas. Smells evoke such memories. I have never since inhaled the scent of freshly ploughed earth without recalling those illicit visits and raw carrots have never tasted so good. Our raiding parties were even more productive when the sweet juicy fruit on the trees was ripe and ready to pick. Plums, plump yellow magna bonums, small, round, honey-sweet greengages, the drier texture of the yellow egg plums, named for their shape and, of course, the stunning deep red Victorias, the all time favourite for jam making and preserving for the winter. After these forays, with pockets bulging and dresses turned up at the hem to enable us to carry away our booty, we would retreat to the railway banks, there to feast on our ill-gotten gains.

As we gradually initiated the newcomers into our country ways, the initial feeling of awe soon gave way to a feeling of superiority. After all, we were on our own territory. However, like children all over the world, we soon accepted each other and life-long friends were made. Graham is not the only one who has never broken ties with that carefree past when we played in the sun, hardly aware of the desperate battles that were being fought almost on our doorstep.

Burton Dassett Beacon and Post Mill

My best new found friends at that time were Daphne Lowry and Pamela Taylor. Daphne was a pretty blonde girl who lived with Mr and Mrs Bird, who were butchers in High Street. She and I were both avid readers and would spend hours lying in the sun on our small back lawn, greedily devouring any book we could lay hands on. I remember we discovered some very old books on ancient history hidden away in the back of a cupboard at school. It was there that I first read of Greek Mythology, ancient cities and people of long ago. My love for these subjects was born and gave me the urge to travel and see these marvels for myself in later years.

Pamela lived with her mother, who was one of the teachers that had accompanied the children. They both lived with Mr and Mrs Hopkins, just over the road from our house. We spent hours sewing clothes for our dolls. Cadging odd scraps of material where we could, or cutting up worn out clothing, salvaging the best pieces. These we would carefully wash and iron before turning them into hand-sewn works of art. We must have owned the best dressed dolls in the village. I remember we even made them matching school uniforms, complete with a sports outfit, hat, shoes and satchel from an old pair of Father's trousers.

I have often thought about Daphne and Pamela and wondered how their lives panned out. Pamela and I used to attend Sunday School on Sunday afternoons, then we would usually go for a walk in or around the village. It was on one of these expeditions that I had my first experience of a darker world. A world in which we were sheltered and not so well informed as the children of today. I suppose because of this, looking back, we must have been vulnerable and at far greater risk. Mr Hopkins was a signalman at Harbury Station and had invited us to visit him that afternoon, when he would be on duty in the signal box, to explain to us the intricate workings of the Great Western Railway. As we walked down the long road towards the station a young soldier passed us riding a bicycle. We were both chattering away, as usual, when a voice from a gate in the hedgerow addressed us asking for directions to the nearest village. We turned, and there stood the young man completely naked from the waist down, his trousers dropped around his ankles. I was petrified, but gathering my wits about me quickly replied – "Sorry, I am a stranger here" and walked on. Pamela, however, being the well brought up young lady that she was, stood there and gave him the explicit directions that he had asked for, carefully averting her eyes from the offending appendage. It seems incredible but we then continued on our way and behaved as if nothing had happened. We were far too embarrassed to tell anyone. In fact, we didn't even discuss the incident with each other!

The old handicraft room used to accommodate the extra pupils was erected on ground which had previously been used to teach the boys gar-

dening. We soon discovered that these children were far less subdued than we 'yokels' who had been brought up in the servile ways of our parents and grandparents and still looked upon our teachers as superior beings. To our delight, some of them actually dared to 'answer back'. Something that we would never have dared to do. We were enthralled on the day that one miscreant actually ran around the desks, shouting abuse and had to be forcibly restrained before being ejected from the classroom. Our admiration grew for these new found allies, who had the courage to flout the authority that we had always accepted as a matter of course.

The songs that they sang during their singing lessons were much different to our 'wishy washy' (or so we thought) songs, such as – 'Drink to me only' and 'Passing by'. Songs that had been sung since Elizabethan times. Their songs were loud and sung with great gusto. Songs where they could really let rip such as 'Charlie is me darling' and 'Dashing away with the smoothing iron'. How we envied them. Even their teachers were different. Why, one young lady teacher even dared to appear wearing pleated shorts for PE, or 'drill' as it was known then, causing much nudging and giggling and whispers of "Look at Miss . . ." A far cry from the tweed skirts, thick lisle stockings and hand knitted jumpers worn by our own teaching staff.

Later on the London evacuees were joined by whole families fleeing from the bombing in nearby Coventry. In fact, descendants of those families still remain in the village today, and are married to some of the members of the old original village families.

Sometimes I think that it would be wonderful to be able to organise a marathon reunion after all these years, but then perhaps not. Sometimes it is best to quietly remember the good times of the past. Memories, like most precious things, are best stored away, only to be taken out at special times. Then, after careful dusting, gently returned to that safe place within the heart.

Chapter Nine
THE LONG, DARK TUNNEL

As the war progressed, we village children were the lucky ones. Our young lives were barely disrupted. To us the war seemed an exciting adventure. Something that was happening far away, whilst we remained cocooned in our safe little world.

The most dramatic event to occur in close proximity happened when a stick of bombs was dropped over the village, resulting in damage to a cottage in Temple End and killing several of Mr Hitchman's cows. The next day, after school, we all trouped down to gaze in awe at the large crater in the middle of the field along Bush Heath Lane. Some of us were lucky enough to salvage our own personal trophies in the shape of a small piece of shrapnel.

A favourite after school venue was created by the arrival of a company of soldiers from the Royal Artillery. They set up a Searchlight Battery in the field next to 'Henry's Cottage' along Bush Heath Lane. Most of them were Welshmen and included amongst them was Frank Evans who later married a local girl and settled in the village after the war. I recall quite clearly lying in bed listening to those wonderful voices, drifting across the open fields as they sang their traditional Welsh songs. The sound of the bugle could also be heard issuing commands throughout their well-ordered day.

On Sunday December 7th, 1941 the Japanese attacked Pearl Harbour. On December 8th Winston Churchill informed the Japanese Government that 'a state of war now exists between our two countries. On December llth Germany declared war on the United States of America. Winston Churchill telegraphed to Antony Eden "The accession of the US makes amends for us all and with time and patience will give certain victory".

We went about our daily business much the same as usual. Attending school but now playing out our own 'war games' choosing equal 'armies' of 'English' and 'Germans'. Off we would go armed with our make believe rifles, creeping silently along the hedges and ditches or laying flat on our stomachs taking cover behind the trees as we advanced. One of our favourite 'battlegrounds' was the spinney opposite the old brick Pound and Lovers Walk where we would lie in wait along the top of the bank ready to ambush the 'enemy' as they unwittingly walked below. There we would descend upon them uttering blood-thirsty cries, ordering them to "put up their hands or be shot". One of the most nerve-racking parts of this game,

I remember, was if you were the unlucky one to be chosen for lone 'sentry duty'. This task involved challenging all comers with the words "Halt, who goes there, friend or foe?" and asking for the password. If you were not alert or vigilant enough this would often result in your own 'capture'. Needless to say the 'English' side always won! We had no idea then that we were repeating history, acting out similar events that must have taken place on that very spot where Hereburgh and her followers built their fortifications long ago.

Illustrated posters appeared plastered on walls and notice-boards in public places everywhere.

Warning us –
Of the possibility of spies bearing such slogans as:
'Careless Talk costs Lives'
'Tittle Tattle Lost the Battle'
'Keep It Under Your Hat'

Advising us –
To learn to identify enemy aircraft for our safety in the event of daylight raids.

Asking us –
'Is Your Journey Really Necessary?'
Petrol was rationed, only available to people engaged on war work and public transport was at a minimum.

Telling us –
'Don't be a Squander Bug'

Asking us –
To buy 'War Bonds' and restrict personal spending. A splendid poster was produced showing a caricature of a large beetle-like insect called the 'Squander Bug' with a face and hair looking remarkably like 'Herr Hitler'. I remember my brother won first prize in a fancy dress competition wearing a costume made by our mother which bore a good resemblance to that ugly anthropod. The body was made from an old sackbag. She took the bristles from a worn out broomhead for the hair and whiskers and the sleeves, cut from a discarded brown woollen jumper were used to cover David's feet and legs.

We were urged to –
'Dig for Victory'
Flower beds and lawns were dug up and utilised to grow vegetables sup-

Ration Book

BA 253578

NATIONAL
REGISTRATION

IDENTITY
CARD

NATIONAL REGISTRATION

Q.M.M.F. | 215 | -

WEBB .
 Gillian M.

1. This Identity Card must be carefully preserved. You may need it under conditions of national emergency for important purposes. You must not lose it or allow it to be stolen. If, nevertheless, it is stolen or completely lost, you must report the fact in person at any local National Registration Office.

2. You may have to show your Identity Card to persons who are authorised by law to ask you to produce it.

3. You must not allow your Identity Card to pass into the hands of unauthorised persons or strangers. Every grown up person should be responsible for the keeping of his or her Identity Card. The Identity Card of a child should be kept by the parent or guardian or person in charge of the child for the time being.

4. Anyone finding this Card must hand it in at a Police Station or National Registration Office.

51—6120 4

NATIONAL REGISTRATION

Q.M.M.F. | 215 | -

WEBB
 Gillian M.
mm 6/3/42

DO NOTHING WITH THIS PART
UNTIL YOU ARE TOLD

Full Postal Address of Above Person :—

10 Brunswick Street
Leamington Spa

(Signed) L. G. Webb.

Date 21/3/42

Identity Card

National Savings Certificate print-out

plementing the food shortage. Acres of public gardens and parklands were ploughed up and planted with potatoes and wheat. Farmers produced more sugar beet to ease the shortage of 'cane sugar' and grew vast areas of corn on meadowland, previously used for grazing stock.

Food was scarce. Ration books were introduced. We were allowed something like two ounces each week of butter, sugar, margarine, cheese, lard and tea (per person). Meat, bread, flour and eggs were also rationed.

Cardboard wedding cakes appeared. These were hollow inside, fashioned to cover over the economical fruit cake made by the bride's mother from ingredients usually contributed by friends and relations, saved for weeks from their meagre allowances. This wedding cake would be cut with the same pomp and ceremony afforded to the traditional three-tier iced cake that today we take for granted.

As we children had never been used to a surfeit of sweets and chocolate, rationing in that area for us caused no hardship. We were only allowed a few ounces each month. Therefore, we chose small things that we could eke out until the next lot was due. Things like aniseed balls that could be counted out in weekly amounts.

We were encouraged to save our pocket money and each Monday morning would arrive at school clutching sixpence to buy a saving's stamp which the teacher carefully stuck onto a card. When we had enough stamps these were converted into a Savings Certificate which I think cost eight shillings and sixpence. These were then left to mature for seven years. I believe that they were then worth, with the added interest, one pound and sixpence.

Many fund raising activities were organised throughout the village. Dances, whist drives and raffles. The money was donated to such organisations as 'The Spitfire Fund' helping to provide more planes and parcels for the Red Cross to send to prisoners of war.

We were all issued with Identity Cards. I still remember my number – QFIR. 56. 3. We were ordered to carry them at all times. The only time that we were ever asked to produce them was one Sunday afternoon when our whole family decided to cycle to Burton Dassett for a picnic. We were just approaching the road leading up to the hills when two armed soldiers suddenly appeared from behind a hedge and challenged us. I was terrified and was convinced that we were going to be shot! In retrospect, a more unlikely looking bunch of spies would, I think, have been hard to find.

As the war progressed clothing, bed-linen and furniture were all added to the list of restricted items. Most of the factories that normally manufactured these things had now gone over to producing armaments and other requirements urgently needed for our defence.

It was amazing what could be utilised in an emergency. Once our mother made a wonderful sandwich cake – with a thick filling of home-

made raspberry jam it tasted delicious. After we had eaten it my mother asked if we had enjoyed it. We assured her that we had and my father congratulated her on her ability to produce such a delicacy given the circumstances. Only then did she reveal that one of the ingredients was liquid paraffin! My father was horrified and declared that he for one didn't want any more cakes that were made with that 'mulluck'. However, I know for a fact that the same recipe was used many times after that, my mother observing the old adage 'what the eye doesn't see' etc., etc., and he continued to enjoy his Sunday afternoon tea cake in complete oblivion!

Sometimes the word would go round like wildfire that the Co-op had received a case of bananas. We would rush down to the shop only to discover that they were reserved, one banana each for children up to the age of five years, holding a 'blue' ration book. By this time we had acquired a baby sister. Believe me, that banana shared into equal minute portions tasted like no other before or since!

It was about this time that my father decided to revive the old country custom of keeping a pig. This was being encouraged by the Ministry of Food who launched a campaign advertising the advantages of forming a local 'Pig Club'. Keeping the family pig, a fashion that had almost died out, was suddenly becoming popular once again. Many of those half-forgotten pig sties sited at the end of cottage gardens had become overgrown with weeds and had remained redundant for years. Now they were feverishly uncovered, garden tools and other equipment removed, whitewashed inside and renovated outside they were once more put to their original use. One pig was allowed for the owner's own consumption. Others were supposed to be sold to the Ministry. As I recall, quite a few of these surplus animals were disposed of through illegal channels.

For the occupants of newer houses it wasn't just a case of building a pig sty. Certain procedures had to be carried out. In his usual meticulous manner Dad carefully drew up plans for his proposed 'porkers' dwelling and submitted them to the appropriate authority. In due course, an official from Southam Rural District Council appeared to measure up the proposed site, and to verify that it would stand within the stipulated distance from our own house and those of our neighbours. Permission was duly granted and building materials ordered. I am quite sure that no stately home during the course of erection could have caused more local interest. Each step of the work was inspected and approved by the members of the Pig Club, Pineham allotment holders as they passed to and fro (digging for victory) and various workmates of my father's who were usually invited to view the latest stage of the project on a Sunday morning. This, of course, enabled any serious technical problems to be ironed out over a pint (or two) down at the 'Dog' before lunch! My brother and I naturally took our

own friends along to receive their valued opinion.

The day arrived when the 'man from the Council' made a final inspection. After testing that the drainage system was in order and other such important items, the building was pronounced passed A1 and the gleaming new abode was ready to receive the first resident. Jack, the piglet, was installed in his new home with due ceremony. We fell in love with him on sight and spent hours replenishing his bed of straw, grooming him, finding him special tit bits of food or generally just hanging over the side of the sty with our friends, admiring and talking to him, or scratching his back with a stick which he loved.

The Sunday morning ritual continued but now comments such as " 'ow many score d'yer think 'ee is now Bert" and " 'ow long afore 'ee 'ul be ready for old Perce then" floated down the garden. Experts such as Bert Morgan, the pig sticker, Perce Cowley, the butcher, and Bert Haines, the miller, poked and prodded Jack with their walking sticks. The poor creature snuffled and grunted with pleasure savouring all the attention, little knowing what fate awaited him. We children, knowing that he was always hungry, unwittingly helped to fatten him up by providing him with more and more juicy snacks. In our innocence we were quite unprepared for that dreadful Sunday morning when our faithful friend was driven all unaware down the village streets to Perce Cowley's butcher's shop in Crown Street. Many tears were shed, our mother cried with us I remember, and no dinner was eaten that day.

Granny Mann's help was enlisted and poor Jack was turned into pork pies, boney pies, lard, black pudding and faggots. Plates of pig's fry were taken around to our neighbours who had contributed their household scraps towards feeding him. In our household only my father ate any of this. Most of it ended up being distributed between relations and friends.

We country dwellers must have been a lot better off than the people who lived in towns and cities. After all, had we not always been more or less self sufficient? Our hens provided us with eggs, our pigs with bacon, ham and occasional fresh meat and most village men such as my father had always been excellent providers of fresh home-grown produce. Our mothers continued to bottle fruit and make jam and wine, for which there seemed no shortage of sugar, and we as always harvested nature's bounty from the fields and hedgerows, including rabbits and hares, as had our ancestors, those hunter gatherers from which we all descend.

The age old system of bartering came once more into its own. A dozen eggs in exchange for a bar of washing soap (which was also rationed) or perhaps a packet of tea for a pat of farm butter. A pound or two of sugar in return for a couple of pots of jam. It became the 'in thing' not to take sugar in tea or coffee.

I remember waiting in line in Leamington with my Granny Taylor outside various cake shops. This was when the word 'queue' came into existence, along with the catchphrase 'if there's more than two, form a queue'. We never knew what cakes or buns would be on offer for that particular day but would gratefully accept whatever was available.

We often heard the words 'black market' whispered during adult conversation. This phrase instilled fear into my childish mind, conjuring up a mental picture of a dark and sinister open air market. Stalls festooned with giant cobwebs hidden away somewhere up dimly lit alleyways, presided over by ugly misshapen monsters. Now, of course, I know exactly where that sack of sugar hidden away under our Granny Taylor's stairs came from, along with the tins of fruit and salmon stored underneath the spare bed!

Groups of us were organised by our teachers at school to gather rosehips, a valuable source of Vitamin 'C'. These were used to make rosehip syrup, which was then made available by the Government to all children up to the age of five. We were paid the handsome amount of fourpence a pound. Proudly I took along to school my first offering. The basket was heavy, full to the brim. The fruits of a whole weekend's 'picking'. I stood in front of the teacher's desk, along with my contemporaries, feeling extremely smug when I compared my own contribution against the small amounts that some of them were clutching in brown paper bags. The perfect crimson berries were carefully weighed and the amount converted into cash by a second teacher. Having already made a swift mental calculation, I stepped forward to receive what amounted then to a small fortune, some already mentally earmarked for various small treats. The most that I had ever earned. Then, as the teacher handed me my hard earned cash, he fixed me with that icy stare that we all knew so well and with an ominous thump, placed the Church Missionary Collection Box firmly on the desk directly in front of me. Now I am speaking of the days when, apart from our parents, the village school master was the ultimate in authority. I knew what I was expected to do and meekly donated the lot! As I listened to the chink of each coin dropping through that small opening my feelings were, I can assure you, anything but charitable!

Despite these setbacks, we youthful entrepreneurs found other ways to assist the problems of cash flow. One of the best 'perks' as far as we were concerned, was in the autumn when, with our parents' permission, we were allowed time off from school to help with the potato harvest on the local farms. A double bonus. Legitimate 'escape' from lessons, coupled with the added incentive of financial reward – the magnificent sum of ninepence an hour.

Our favourite farmer was Mr Tudor from Chesterton House Farm in Mill Street. One of the chief attractions as far as we girls were concerned

was his young nephew who drove the tractor. With his auburn hair and
'geordie' accent he set our young hearts a-flutter. Each morning we set off
from home carrying our own buckets for picking, packed inside with an
ample supply of food and drink. Our mother provided us with delicious
home-made apple and jam turnovers, cold bacon jack and huge wedges of
spicy bread pudding, knowing that a whole day out in the fresh air would
stimulate our normal healthy appetites even further.

After assembling in the farmyard, all agog for a first glimpse of 'our
hero', we would clamber onto the wooden trailer, jostling for a place near-
est the tractor driver, sitting importantly amid the piles of sackbags and
extra buckets. Off we would go, riding through the village. When we
reached the school our unlucky school fellows, having heard the tractor
approach, would be peering through the wooden railings which were set at
the end of the girls' playground. With feelings of superiority we would be-
stow upon them a pitying glance and a nonchalant wave as we passed by.

Working in pairs we picked up the potatoes contained in an area marked
between two sticks that was paced out beforehand by one of the farm
workers. We were very competitive, each pair trying to outdo their neigh-
bours by attempting to clear their allotted piece of ground first. The
quicker we were able to do this the longer rest time we had, sitting on the
upturned bucket, before the tractor came around once again. We emptied
our buckets of potatoes into sacks which were placed in rows down the
side of the field. From there, when full, they were loaded onto an open
sided horse-drawn cart. Some were taken off immediately for sale and oth-
ers were buried in long clamps covered over with straw and earth for use
later in the year.

How we enjoyed those crisp October mornings when our breath rose
and hung in the air like smoke as we passed the hedges and trees festooned
with cobwebs, their delicate patterns encrusted with tiny dewdrops resem-
bling the glittering decorations beloved by us all at Christmastime. The
smell of freshly dug earth. The straight dark brown furrows left behind as
the digger passed by revealing the harvest of potatoes beneath, posing a
further challenge to our speed and expertise.

The ever present flock of birds following in the wake of the tractor.
Sharp, beady eyes searching for the feast of grubs and worms exposed on
the earth below, turned over by those sharp flashing blades. Then rising,
screeching and wheeling high in the sky above, turning as one into the
morning sun, their wings transformed into beaten silver by that sudden
shaft of light.

Mr Tudor always returned to the farm for his lunch. Most of us chose
to accompany him, I think merely for that extra trailer ride. We ate our
lunch in the huge loft on top of the barn facing into the farmyard, washed

down with mugs of piping hot tea brought out to us in a huge enamel jug. There we would sit devouring our doorstep sandwiches down to the last crust, legs dangling through the opening watching the gaggle of noisy geese down below as they paraded, resembling a platoon of soldiers, guarding their domain. How I hated those geese and still remember the fear they evoked when we were forced to run the gauntlet each time we crossed the yard.

For the first day or so we would suffer with aching legs and backs, which was soon relieved by a long hot soak in a bath which our mother would have prepared all ready for us when we arrived home. That small inconvenience was soon forgotten by the sight of the blue card signed by the farmer each day confirming our hours of work. An aching back was a small price to pay when we were receiving the princely sum of ninepence an hour!

A campaign was also launched by the Government designed to combat the shortage of clothing which was now obtainable only by spending our precious 'clothing coupons'. The slogan 'MAKE DO AND MEND' appeared in magazines and the national press. Helpful hints were printed and special economy patterns were designed. For instance, how to turn the legs of a discarded pair of men's trousers into an attractive and fashionable skirt. Garments were specially made without pleats or gathers to cut down on the amount of material required. Men's trousers were produced without 'turn-ups', coats without collars and pockets.

Linen cupboards and storage trunks were ransacked to reveal discarded car rugs and blankets that had long been hidden away and forgotten. These were turned into smart winter coats. It became not only acceptable but downright patriotic to wear second hand and 'made over' garments. It made not a scrap of difference to us for had we not always accepted this as the norm?

Fashion followed the trend of the times and assumed the lines of uniforms and distinctive clothing worn by our service men and women as well as that adopted by such public figures as Winston Churchill. The all-in-one zipped up 'siren suit' so popular with our 'man of the moment' was knitted by mothers and maiden aunts and worn by children all over the country. I recall my sister Gillian wearing a pink and blue version that was carefully created out of wool unpicked from two old jumpers. When Princess Elizabeth appeared in a suit designed after the style of that worn by the girls of the ATS (the service that she later joined as a Junior Officer), complete with a version of the smart peaked cap, the outfit was received with great acclaim and was copied and worn by young women everywhere.

Khaki balaklava helmets and gloves such as were produced for the troops in great numbers, along with socks and scarves, by voluntary knitting circles, were a favourite mode of dress with young boys, including my own brother. We girls, I remember, wore knitted mittens and a type of hat

100 Keck, Cowpats and Conkers

made from two flat knitted squares which, when sewn together, formed a peak at the back, and tied under the chin with a crochet cord, known as 'pixie' hats. They were usually made from all the odd scraps of wool left over from larger works of art. Mine, I remember, was knitted in bands of many colours and further adorned with a cluster of multi coloured embroidered lazy daisy flowers over each ear. We must have resembled a collective clutch of diminutive garden gnomes as we wended our way to school.

Music and laughter played a major part in our lives at that time, organised to boost the morale of the people and the armed forces during those dark days. Variety shows and popular comedians, singers and actors entertained both at home and in all theatres of war, in Europe, the Middle and the Far East.

Comic songs were sung in defiance hurling insults at the enemy. Cartoon characters based on Mussolini and Mr Schickelgruber, the Austrian paper hanger, Herr Hitler's real name and former profession. Vera Lynn became 'The Sweetheart of the Forces'. Who could ever forget her rendition of 'The White Cliffs of Dover' and her signature tune 'We'll Meet Again'?

Flannagan and Allen sang 'Underneath the Arches' and 'Hometown'. Gracie Fields gave us, in her own inimitable fashion 'Wish me Luck as you Wave me Goodbye'. Songs such as 'Who do you think you are Mr Hitler', 'Bless 'em All', 'We're Gonna Hang Out the Washing on The Siegfried Line', 'Kiss me Goodnight Sergeant Major' and 'The Quarter Master's Stores' were whistled and sung everywhere along with tunes from the 1914–18 War 'Pack up Your Troubles in your Old Kit Bag' and 'Tipperary'.

The BBC broadcast 'Music While you Work', especially for war workers, twice a day and a variety show entitled 'Workers' Playtime' was relayed each lunch-time from a factory, 'somewhere in England'. Factories, including the 'Lockheed Works' in Leamington formed their own concert parties. The Lockheed Pantomime became an annual event, a 'must' for local people and continued long after the end of the war with Dixie Dean, a well known character from Bishops Itchington, playing the Dame.

Then the Americans joined the war, bringing with them the 'Big Band' sound of Artie Shaw and Glen Miller, who was tragically lost in 1944, somewhere over the English Channel. The plane, along with its other occupants, was never recovered.

Comedians such as Tommy Handley in his guise as Mayor of Foaming-at-the-Mouth. The programme which contained those silly catch-phrases that we all repeated. Colonel Chinstrap, played by Jack Train, slurring his inebriate, ever hopeful comment of 'I don't mind if I do' in answer to any question, no matter how irrelevant. Mrs Mopp, the chirpy char-lady asking 'can I do yer now Sir?' The phantom telephone caller announcing himself with the gutteral words 'dis iss fumph speaking'. The voice with accom-

panying bubbles, begging 'don't forget the diver sir, don't forget the diver', and other mad characters such as Dan Druff, the demon barber, and Arthur Askey and his silly 'Bee' song.

Theatres everywhere provided glamorous entertainment for the troops and civilians alike. Theatres such as the 'Windmill' in London, with their proud boast 'we never closed', not even during the worst nights of the Blitz.

We were now quite used to seeing men in uniform wearing distinctive shoulder flashes denoting their country of origin such as Poland, Czechoslovakia and France. The Australians and New Zealanders were easily identified by their large slouch hats turned up on one side.

The arrival of American troops caused much interest. Very few of us had ever seen a black man. I thought that all Americans must be officers because of the superior uniform they wore. Local girls were obviously attracted to these smart looking, crew cut, gum chewing charmers with their easy going manner and generous ways. They certainly livened up the weekly dances in the Women's Institute Hut, exhibiting their prowess as they introduced the Jitterbug and the Jive, not easy in such a confined space. The sight of a Jeep cruising around the village streets soon became an everyday occurrence. We children welcomed them with enthusiasm upon discovering a seemingly unending supply of chewing gum which they generously donated!

Many large country houses were taken over by the 'War Office' and used as hospitals and nursing homes for the treatment and recuperation of the sick and wounded. The patients soon became a familiar sight dressed in their special blue uniforms.

As the war turned in our favour, German and Italian prisoners of war also became a familiar sight working on the local farms wearing coloured patches sewn onto their uniforms for identification. I remember if a 'gang' of us met any of them whilst we were playing in and around the fields they would always ask us for the correct time. We had been told by our father not to have anything to do with them. I remember thinking how lonely and sad they looked. Not a bit like the cruel, arrogant men that we had visualised. In fact they looked no different to our own father!

In the weeks leading up to D-Day, June 6th, 1944, long columns of marching troops, vehicles and equipment became a common sight, making their way down country towards the south coast. We could hear the sound of marching feet and the rumble of heavy lorries passing through the village as we sat at our desks, inwardly cursing our Victorian benefactor for placing the windows so high up. It seems incredible that even then it all seemed nothing more than an exciting game. On the day of the Normandy landings our teacher produced a large map of the area and explained the situation in exact detail. It was only then, I think, that I real-

ised what was happening on our own doorstep and the serious implications should the operation fail.

Perhaps this was simply because I was just a small child in September 1939 and, therefore, had grown up accepting the situation. Or was it, that living in a small village in comparative isolation I had been sheltered from the reality of war, living in a kind of 'time warp', or maybe that was the day that I just 'grew up'.

Whatever the reason, I still remember with great clarity those first tense days after the invasion. The little flags on our map moved forward further inland away from the French coastline as our troops advanced. The war continued for almost another year. But, with each small victory the light at the end of that long dark tunnel grew brighter and we would see that the end was in sight.

On May 8th, 1945 VE Day (Victory in Europe) was announced. It seemed that the whole nation went wild with excitement. There was singing, dancing and laughter everywhere. The village streets were thronged with people hugging each other and shaking hands. The feeling of intense joy and relief was indescribable.

The war against Japan continued until – On August 6th, 1945, at 8.15 am Japanese time, the first atomic bomb was dropped by the Americans on Hiroshima. On August 9th a second bomb was dropped on Nagasaki. At mid-day on August 15th the Japanese Emperor announced to his people his Government's decision to surrender.

So ended the Second World War after almost six years.

Families could now eagerly await the return of their loved ones. Many had been away from their homes serving in the Far East for several years. Others had endured the indignity and, in many cases, the harsh treatment meted out to some prisoners of war and would consequently bear the mental scars for a lifetime.

Throughout the long years of war whenever the inevitable messages of 'Killed in Action' were received the whole village mourned, sharing a deep and personal sorrow, together with often weeks or months of terrible anxiety when that small official envelope contained the word 'Missing'. These were our young men. Some had been born into families that had dwelt in our small community for decades. We all knew them. They had attended the village school, church and chapel. Had worked, played, laughed and loved amongst us.

How could we not grieve together?

Ten names are inscribed on the roll of honour in the village church. They also appear on the memorial in Crown Street, alongside those of the men lost in the First World War 1914–1918.

'LEST WE FORGET'

TOM BIDDLE
ROYAL ARTILLERY
Killed during the Normandy Landings 1944.

HARRY AND GEOFFREY BOYNTON
ROYAL WARWICKSHIRE REGIMENT
brothers, who were killed in 1944, only ten days apart.

RAY CENEY
GRENADIER GUARDS
Lost after the battle of Dunkirk 1940. Destined never to know the son, so active today in village affairs.

DENNIS DALE
ROYAL MARINES
Lost aboard HMS Neptune.

ERNEST ('ERN') FIELDS
ROYAL CORPS OF SIGNALS
Killed in Germany April 1944. Remembered by many as the happy-go-lucky baker, roundsman for Harbury Co-op.

REX GURDEN
RAF
Failed to return after a bombing raid 1941.

JOHN (JACK) HODGES
ROYAL WARWICKSHIRE REGIMENT
Lost at the battle of Cassino, Italy 1944. Also destined never to know his son.

R. W. MORRIS

GEORGE TANNER
ROYAL NAVY
Lost aboard HMS Boadicea.

WHEN YOU GO HOME, TELL THEM OF US
AND SAY "FOR YOUR TOMORROW
WE GAVE OUR TODAY"

NOTICE **HG** 659649

1. Always carry your Identity Card. You may be required to produce it on demand by a Police Officer in uniform or member of H.M. Armed Forces in uniform on duty.

2. You are responsible for this Card, and must not part with it to any other person. You must report at once to the local National Registration Office if it is lost, destroyed, damaged or defaced.

3. If you find a lost Identity Card or have in your possession a Card not belonging to yourself or anyone in your charge you must hand it in at once at a Police Station or National Registration Office.

4. Any breach of these requirements is an offence punishable by a fine or imprisonment or both.

FOR AUTHORISED ENDORSEMENTS ONLY

51-266

NATIONAL
REGISTRATION
IDENTITY
CARD

FOR OFFICIAL ENTRY ONLY (apart from Holder's Signature). ANY OTHER ENTRY OR ANY ALTERATION, MARKING OR ERASURE, IS PUNISHABLE BY A FINE OR IMPRISONMENT OR BOTH.

Identity Card

Chapter Ten
LEARNING THE THREE 'RS'

The old Wagstaffe School is one of the oldest stone houses remaining in Harbury today. Founded by Thomas Wagstaffe in 1611, a stone tablet set into the wall above the main entrance gives testimony to this. The house was used continuously as a school from 1759 to 1967, when a new school was built on the site of what we village children once called the 'Daisy Field', part of the parklands belonging to the existing Manor House.

The wealthy Wagstaffe family resided in the village for several generations. There is a brass in the church bearing the name of Alys Wagstaffe dated 1563 and a plate dedicated to Anne Wagstaffe dated 1624. One of the original manor houses was granted to John Wagstaffe in 1546 and although, after four and a half centuries, there is no documentary evidence to support the claim, it has always been assumed by the village people, those whose roots are firmly buried along with the past history of Harbury, that the Dovehouse, partially demolished in 1967, was once part of the great house which stood on or near that spot. Another example perhaps of local knowledge handed down through successive generations.

On the completion of the new school in 1967, the old Wagstaffe School House was sold and is now beautifully preserved as a private dwelling.

I was three years old when my mother took me along to meet May Bird and Helena Rainbow, teachers who although complete opposites in approach and personality, were equally dedicated towards shaping our young lives during those important early years. May Bird was one of the last 'pupil teachers'. These were girls who had received no formal training but stayed on at the village school after the age of fourteen, carrying out their duties under the supervision of a qualified teacher.

The little room to the left of the main entrance was her domain where we remained in her care up until the age of five. She was a small, plump, motherly lady who, I seem to remember, favoured wearing the colour brown. Her dresses were all made in a similar style, cut with a deep 'vee' neck in which she wore pretty lace inserts which I believe were called 'modesty vests'.

Here we began our education, including the basic art of acceptable so-

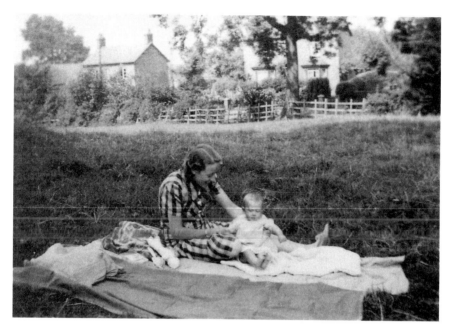

Aunt Gladys Mann and me in the Daisy Field
now the site of the present school

cial behaviour, such as eating with our mouths closed and putting a hand
over our mouth if we were rude enough to yawn or cough! Little boys were
encouraged to open doors, then stand aside allowing the girls to walk
ahead. Also, to raise their caps (which they all wore) when meeting a lady
in the street.

Although it all happened so long ago, I only have to close my eyes to
recapture the scene. There before me I can see so clearly the tiny wooden
chairs and tables at which we sat. Sometimes drawing pictures with thick
chalks on black paper or cutting out patterns from shining, sticky backed
squares that seemed to glow like so many semi-precious jewels covering the
whole spectrum of colour and shades, making it so hard to select the right
ones to use on that all important work of art that perhaps, if we tried hard
enough, would be among those chosen to decorate the walls of our cosy
little classroom.

How proudly we all wore the crowns which we made on the occasion of
the coronation of George VI and Queen Elizabeth in 1937. These we cov-
ered in gold paper and decorated with 'cut out' rubies, emeralds and dia-
monds.

We were taught how to knit on thick, short, wooden needles. I can never

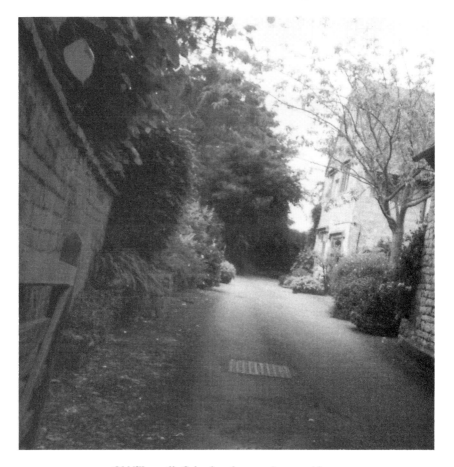

Old Wagstaffe School, today a private residence

remember any of us actually completing a recognisable article until much later when we progressed onto dishcloths. These were then proudly presented to doting grandmothers for presents at Christmastime. I suppose the 'dropped' stitches went unnoticed on such lopsided, grimy looking pieces of handiwork which, when finished, were apt to resemble crude cobwebs spun by over-large spiders in urgent need of the ministrations of an optician!

The classroom was heated by an open coal fire, surrounded with a heavy black fireguard, usually hung about with umpteen pairs of small knickers, proof of training still needed in yet another area of the social graces!

Miss Bird never went home for her dinner but brought to school each

day a meal contained in a small covered enamel basin. This she would place carefully on a brass trivet in front of the glowing fire to slowly warm through as the morning progressed.

At twelve o'clock we all went home to dinner. On the command 'Hands together, eyes closed' we would gabble 'grace', then start that long route march home in all weathers. Not for us or our mothers the convenience of school dinners followed by supervised play. When we returned to school in the afternoon often we were asked by Miss Bird to stand up one by one and, facing the class, relate what we had been given that day to eat for our dinner.

This became a kind of competitive 'one upmanship' game. As the teacher progressed around the room all leanings toward the truth were abandoned and menus fluctuated from the exotic to the outrageous as each child tried to outdo the other. I now suspect that this was done as a check carried out by her in her auxiliary role of social worker to ensure that we were getting adequate nourishment in those times of great hardship caused by vast unemployment.

When the weather was fine we spent a great deal of time outside in the playground under the shadow of the huge trees that then grew alongside in the churchyard. We had a wonderful and varied selection of toys. There was also a sand pit and a wooden climbing frame. As it was a Church of England school I imagine these would all have been donated through that particular channel.

The vicar, Mr Albert Capps, was a frequent and popular visitor, joining in our games and taking over our Scripture lessons as we progressed further up the school. Although Harbury school today is no longer financed by the Church, there remains still a Church School Council, headed by the vicar, who takes an active part in school affairs.

Singing games such as 'Oranges and Lemons' were very popular. What fun it was to stand at the head of a column of laughing boys and girls, facing your chosen partner, with hands outstretched to form a bridge, waiting as they passed beneath to 'chop off' the last man's head. A nursery rhyme whose origins date back to Henry VIII recalling his unpleasant habit of decapitating any unfortunate being that fell into disrepute, including two of his own wives!

Another favourite singing game was called 'The Farmer's in his Den'. Forming a large circle we would chant the words, dancing round and round, each one of us secretly hoping to be called into the centre, chosen as the farmer's wife, child or nurse, and so eliminate the possibility of being chosen as the farmer's dog, suffering the inescapable physical battering as each child enthusiastically 'patted' the unfortunate, make believe animal!

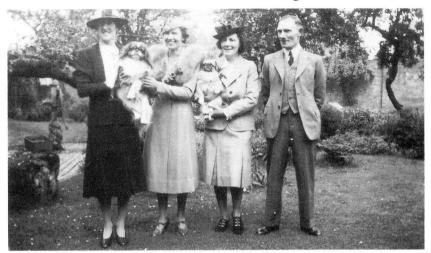

Miss Helena Rainbow's wedding in 1941.
Sisters Elizabeth Rainbow, Elsie Rainbow, left, and brother Reg from Pineham Farm

Each afternoon we rested on small fold-up canvas beds, ranged in rows. Inside when cold or wet, outside when fine and sunny. We each had our own small blanket, identified by a personal motif. Mine was a giraffe, which also appeared above my coat-peg and was embroidered on the small linen hand towel and drawstring bag that was taken home to be washed each weekend. In the cloakroom stood a row of minuscule washbasins. A refinement light years ahead for most of us.

The lavatories at the bottom of the yard were a scaled down version of the smelly wooden seated conveniences that we were all well acquainted with and that were to remain with us until the mid 1950s when the mains sewage system was introduced to the village.

At the age of five we graduated into the 'big room' under the watchful eye of Miss Rainbow, a gracious lady where, with her soft voice and charming smile, she created the calm, secure environment so essential to small children of that most vulnerable age.

Although I was only a small girl I still remember how I admired her neat, coordinated dress sense. On her wedding day, when she became Mrs Harris, she wore a pair of pale grey, soft kid, strappy shoes. I had never seen such elegant footwear in my life and resolved then and there that when I grew up I would buy a pair just like them.

The pattern of our days changed and although we were still allowed time for play the serious business of learning the three Rs began. We learned to read and write and to recite our 'tables' parrot fashion. We were weaned away from the infant nursery rhymes and were taught traditional

songs, poems and hymns. The Church and its teachings in those days play-
ing an important part in our curriculum.

By the time we reached the age of seven we had already received a good
grounding in the basic academic skills and most of us were only too eager
to move on to the Wight School in High Street which now accommodates
the County Library and a play group.

The Wight School was built in 1856 by the Reverend William Wight to
provide an education for village children who, for the most part, went on
to become farm workers and domestic servants. Below is set out a copy of
the original rules of the schools:

Rules of the Harbury Schools, 1852

*Books, slates, maps etc. will be provided free of any charge. Copy books, and
books used out of school hours will be an extra charge. And no books will be al-
lowed in the school but what are there obtained. The school payments are as fol-
lows:*

1. *Farm labourers' children: one child 2d, two children 3d, 3 children 4d. Me-
 chanics' children, one child 3d, two 5d, three 6d.*
 Tradesmen's children 4d.
 *Professional men's children, and those in affluent circumstances, ten shillings
 per quarter.*
 An extra charge for children not living in the parish.
2. *No contracting of debts will be allowed. All payments to be in advance, and
 any child not bringing his pence on Monday morning will be sent back and
 refused admittance until the money is brought.*
3. *Any child coming to school dirty or with uncombed hair will be sent back.*
4. *Any child found guilty of dirty habits, bad language or any improper conduct,
 and persisting in such conduct after having been duly admonished will be
 expelled the schools.*
5. *The school will open at a quarter before nine in the morning and at a quarter
 before two in the afternoon, a singing or drilling lesson will occupy the time
 till nine in the morning and till two in the afternoon. And as the lessons will
 begin punctually at nine and at two, any child coming after would render it
 necessary to recommence the lesson; a child coming after nine or two will be
 liable to be sent back.*
6. *Any complaints about the school must be made to the vicar. And to secure the
 school from interruption no person will be allowed to visit it, without an order
 from the vicar, who daily inspects the schools himself*

Parents must bear in mind that strict compliance with the above rules is neces-

sary to ensure the efficiency of the school.

Parents are likewise earnestly requested, so to arrange their domestic affairs, that, except in very urgent cases, the children may never be kept from school. Let parents always bear in mind, that six months regular *attendance will do more for their children than twlve months* irregular *attendance.*

It is in contemplation to combine the industrial training with the intellectual course of instruction. To prepare the children for the duties of public and private life. To qualify some for the office of teachers and other employments, and some for domestic service. The first class girls will, three days in the week, be instructed at the vicarage, by efficient servants, in household duties, and to such as may wish for situations testimonials will be given after having acquitted themselves satisfactorily. To prevent any interruption of their school duties, the girls will attend at the vicarage from eleven till two and dine at the vicarage. By this arrangement only two hours in the week will be taken from school, as one of the days selected will be Saturday, when there is a holiday.

I had enjoyed school from day one and still remember that feeling of excited anticipation as we marched in twos down the village from the 'Little School' to the 'Big School'. Alas, I am not sure how it happened but for some reason or another I managed to make myself extremely unpopular with the young teacher that took Standards One and Two. It seemed that every other day I was being called out in front of the class, there to receive a hard rapping over my knuckles with a wooden ruler. It was then that I made a vow never to physically abuse any child in my care. I realised even at that young age that that kind of treatment serves no useful purpose, breeding only fear and resentment.

My favourite subjects were History and English. I hated Arithmetic which to me was a nightmare. I never mastered decimals or fractions, much to my father's disgust. Although he himself had left school at twelve years of age, he had taught himself the basics of mathematics and could never understand why, in his own words, "I was so stupid". Night after night, he would sit with me starting off very patiently, becoming more and more frustrated as it became clear to him that I just could not grasp the subject. I began to dread those useless lessons and can only describe my feelings as if a blanket were thrown across my brain causing a complete void.

I was an avid reader from a very early age, this is something that has remained with me throughout my life. I remember when I was seven years old in Standard One discovering that the glass fronted cupboard in the classroom contained some wonderful old books, a veritable feast of knowledge. It was from these that I first learned of the Ancient Greeks and Romans and the wonderful stories of their gods and of the ancient cities

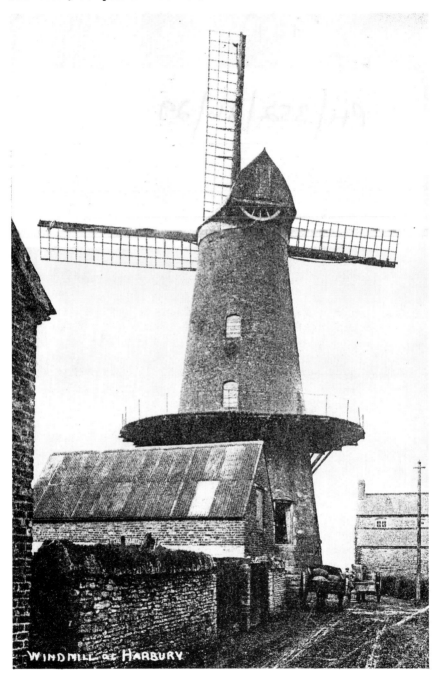

Harbury Windmill, now converted into a private dwelling

and tombs, many of which I have been privileged to visit.

In the summer we often went for long nature walks where we learned to identify the wild flowers, trees, birds, insects and animals. Most of us were already very knowledgeable in this area having been taught by our own parents who were born and bred country folk. Once a local farmer took our whole class around his farm explaining to us the different crops and their uses.

We then visited Bert Haines at the mill. There we watched the grain being ground into flour. Harbury windmill, built in the early 1800s on the site of an earlier mill, possibly a wooden post mill, has now been restored and converted into a unique private dwelling, saving the building from the fate of so many others in the area that were mainly left to fall into disrepair, then to vanish completely. As well as providing an interesting historical past, this old building has been witness to at least one local tragedy. The following report appeared in the Leamington Spa Courier dated March 18th, 1893:-

<center>

Fatalities at Harbury
Shocking Death In a Windmill

</center>

The two shocking fatalities at Harbury on Thursday and Friday last week, threw that usually quiet village into a state of great excitement. The first refers to George Frederick Verney (27) miller, who while engaged in working his mill, late on Thursday night, it is supposed, fell and got entangled in the upright shaft, his legs being horribly mutilated. He evidently died in great agony. Full particulars will be found in the report of the inquest, which is given below. The second death was that of Mrs Eliza Boote, widow of Mr C. Boote, of Harbury, who, it appears, went to Verney's house to try to comfort her niece (Verney's wife) in her sad bereavement. It is stated that Mrs Boote had a desire to see the deceased, but before doing so, was so overcome that she herself died almost instantly. Having been suffering from heart disease, the Coroner did not think an inquest necessary.

The inquest on the body of George Frederick Verney was held before Mr D. R. Wynter (Coroner for Central Warwickshire) at the New Inn, on Saturday afternoon. Mr John Horley was Foreman of the jury.

William Verney, father of the deceased, stated that he was a threshing machine proprietor, living at Harbury. The deceased was twenty-seven years of age last October, and had resided at the Mill House for the past three years. Witness last saw him alive on the Wednesday morning previous. Deceased was in the habit of working at night when there was a good wind, and had worked many nights recently. Deceased knew all about the working of the mill and generally worked it alone. He thought it very

probable that the deceased was in the dark, and that his clothes caught in the upright shaft. There was a pane out of the window close by, and he thought the draught from it would have blown the light out if deceased had passed it by. Sometimes the flour wanted poking down, and that would necessitate his having to go close by the window. Deceased's clothing might have caught in the rope which was coiled round the upright shaft.

The Foreman said he should think the accident might have occurred in the way suggested, as the rope was covered with blood. No doubt deceased did trip up over that rope, and fall against the shaft.

Edmund Edward Griffin said he was a carpenter and joiner, residing at Harbury. He knew deceased well, and met him on Thursday night, at about nine o'clock. Deceased was then taking a light up the steps into the mill. Witness told him to stop a minute or two till he could fetch his tools out, as they were in the mill. Deceased did so, and asked witness if he was going to make his uncle's coffin. Witness replied that he was. Deceased said that he could not make room enough for witness to work at it in the mill that night but added that, if he wanted anything else they could see about it in the morning. Witness went home. Deceased told witness he was going to work in the mill the "night through" and that was the reason he could not have the bench. Deceased was quite sober at the time.

Thomas Berry, a haulier, residing at Harbury, said that about ten minutes to eleven on Thursday night, as he was going to bed, Mrs Verney came into his house and said that her husband had not come home; she hoped nothing had happened to him and asked him if he would go down to the mill to see, as she was frightened. Witness asked the last witness to go with him and they and Mrs Verney all went down to the mill together. She supplied them with a candle and they went up into the mill, witness going first. The mill was quite still at the time but when witness got to the floor next to where he found deceased, it started to go. He went up the next pair of steps and saw deceased going round with the shaft. Witness noticed at once the extent of the injuries to deceased, and ran and put the brake on to stop the mill. Having done that, he then ran for the doctor and assistance. The doctor came in less than three minutes. Verney was dead when witness first saw him, and he should think he had been dead quite an hour. He saw the rope in the cog above, but deceased was perfectly clear from any rope. He also saw the lantern picked up afterwards. It was broken to pieces. He thought it probable that the lantern went out, and deceased, catching his feet in the rope, was taken up. By a juror: The mill was in full cloth, and was going when witness went to see to his horse between nine and ten o'clock that night. It afterwards stopped, and a flush in the wind started it again. Deceased had his arm around the shaft, as if

in a death clutch. When found he was close to the ground, and quite away from the cogs.

The Coroner, in summing up, said there was not the slightest evidence or suspicion whatever of any foul play having taken place.

A verdict of "Accidental death, resulting from being entangled in the shaft of the mill" was accordingly returned.

A juror (Mr Green) said he should like to draw the attention of the jury to the dangerous state of the mill from dilapidations. There were no means of governing or stopping the mill except from the stage, which was in a rotten condition, being unsafe for anyone to walk upon. He contended that means of putting on the brake and stopping the mill should be provided on each floor. Even if two persons were working the mill, and one got entangled, it would be impossible for the one to save the other, as one would have to run down the stairs and out on to a dangerous platform before the mill could be stopped. That was the only way the mill could be stopped, and there were seven floors to it.

Other jurors concurred in those remarks.

Our next visit was to Mr Thornicroft's bakery in Chapel Street. There we were given a demonstration of bread making and baking and were given edible samples, much to our delight!

Singing lessons were also great fun. Mr Edgar Dickens, our headmaster, always presided over this himself. He was a great character and came from the nearby village of Stockton at the beginning of the century as a young unmarried man and remained to teach several generations of Harbury children until his retirement after the Second World War. His wife came out of retirement during the war to teach us needlework when we made shapeless nightdresses and blouses. She had a habit of rapping loudly on the desk, commenting "Gels, hands off your garments". I remember once getting into serious trouble when I asked what I thought was a logical question, which was "How could we sew them if we were not allowed to touch them?".

We sang traditional English, Welsh, Irish and Scottish songs. 'Men of Harlech', 'The Minstrel Boy' and 'Scotland the Brave'. Old May Day songs 'Now is the Month of Maying' and 'Come Lassies and Lads'. Old English love songs, some going back as far as the days of William Shakespeare. Some attributed to King Henry VIII 'Drink to me Only', 'It was a Lover and his Lass', 'Greensleeves', 'Strawberry Fair', 'Oh No John', 'Richmond Hill', 'Passing By' and many, many others that our fathers and their fathers had sung before us. There were the rousing sea shanties 'Hearts of Oak' and 'Shenandoah' and marching songs like 'The British Grenadiers'. These we sang with great gusto until the very rafters rang,

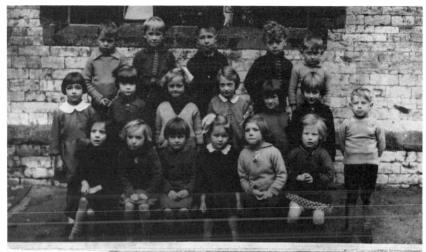

Wagstaffe School Group – 1935
Back row: Donald Hall, Ray Johnson, Bernard Wyatt (?) Gerald Gurden,
Middle row: Kathy Sollis, Esme Bayliss, Ruth Barratt, Barbara Biddle, Flora
Humphries, Yvonne Kitchener, Peter Sheasby
Front row: Frances Mann, Doreen Bloxham, Evelyn Gardener, Doris Biddle,
Margaret Messer, Lucy Lines

conducted by Mr Dickens who, growing red in the face, would leap up and down beating time with his cane and encouraging us with shouts of "Louder, louder".

'The Lincolnshire Poacher', 'John Peel', 'The Farmer's Boy' and 'The Vicar of Bray' were other stories in song that marked significant happenings, battles and the exploits of individuals, both famous and infamous, all linked with our past history.

Poems that we were made to learn by rote I can still recite today 'The Passionate Shepherd to his Love' by Christopher Marlowe 1564–1593, Shakespeare's sonnet 'Shall I Compare thee to a Summer Day' and 'O Mistress Mine' from Twelfth Night. 'The Bounty of our Age' by Henry Farley – 1621. Also psalms and passages from the Bible.

In those days, large areas of the map of the World were coloured red showing the extent of 'The British Empire'. Empire Day was always celebrated. One year I was chosen to represent Britannia, swathed in a Union Jack and wearing a huge helmet and carrying a shield in one hand and

a trident in the other. We had no idea then that we were in fact witnessing the end of a great era.

We were made to recite 'Patriotism' by Sir Walter Scott and 'Play Up, Play Up and Play the Game' (Vitai Lampada) by Sir Henry Newbolt instilling into us the Englishman's love of his country and his equal passion for fair play.

The girls and boys had their own individual playgrounds divided down the centre by a wooden fence and PE or 'Drill' as it was then called was taken in separate groups. A female teacher for the girls and a male teacher for the boys. We had no special games kit, we just tucked our dresses inside the voluminous navy blue knickers that we all wore (along with our shapeless liberty bodices) complete with pocket containing a hotch potch of articles such as marbles, the odd penny and a scruffy handkerchief wrapped around a half eaten, sticky 'gob stopper' or, later on when it became popular, hastily discarded, soggy chewing gum.

Sports Day took place once a year during the summer months. We were all divided up into teams and wore bands of red, yellow, blue or green, depending upon which team we were representing. At the end of the day the winners would be presented with the shield that hung on the wall in the main classroom. This would then be decorated with the appropriate coloured ribbon.

Periodically the school nurse, Nurse Fletcher, would appear to scrutinise our heads for lice and in between our fingers for Scabies. Nearly always the same people were sent home bearing a small jar of an obnoxious concoction with instructions to their mothers to anoint the affected parts. She would then call at their homes before they were allowed back at school. With the usual, cruel, pack animal instinct of most children they soon became ostracised by the rest of the class and nicknamed 'stinky' or 'smelly pants'!

Country dancing was another favourite lesson for which the butcher's wife, Miriam Alcock, played the piano. I still recall the fascination of watching the long drop earrings that she wore madly swinging to and fro as the music gained momentum.

The Wight School rooms were heated by coke stoves and a system of hot water pipes that ran around the walls served by a coke fed boiler outside. These pipes, on cold days, were used to warm gloves, scarves (and bottoms) as well as our mid-morning bottles of milk introduced by the Government some years before as a free vitamin supplement available to all school children.

The old wooden desks held two pupils and were fitted with a lift-up lid. A groove ran along the top to hold the wooden pens that we used. The

loose pen nibs pushed directly onto the end of these. Small white ceramic ink wells dropped into holes especially provided at the top of each desk. A great honour was to be chosen as Ink Monitor when the lucky child went around each Monday, smirking with importance, checking and replenishing the ink from a large can with a long thin spout. Not so lucky were the people who were given the unenviable task of washing out the dirty ink wells! These were usually miscreants unfortunate enough to be caught throwing pens up into the open rafters where they quivered and hung for posterity.

Some of us 'jumped' a Standard at the beginning of the school year when we were automatically moved up the academic ladder. That was fine lower down the school but not so good as we became older and had finished the syllabus at an earlier age. This meant of course that our services were used as messengers and minders of the younger children during the absence of a teacher.

I remember well those hot summer days when we were incarcerated inside our classroom gazing up at the clear blue sky through the windows that had been built high up by our Victorian patrons, no doubt to deter any distraction from study. This, however, had the opposite effect on me and, to escape the tedium, I would often retreat into a dream world of my own, only to be rudely awakened from my reverie by a sharp, stinging blow behind the ear from a piece of chalk or the blackboard rubber being thrown across the room by an irate teacher. Another 'punishment' was being sent to stand outside in the porch for the rest of the lesson – for me a welcome relief!

It was no good going home to complain to our parents as we would almost certainly receive a clip around the ear for misbehaving! So, for the most part, we suffered in silence. But then, those teachers probably felt equally bored, suffering the frustration of trying to cram the Three Rs into we village children, slow of speech and lacking in stimulation. When I compare today's opportunities against the almost non-existent chance of further education then, I can understand the feeling of apathy and rebellion that existed. For only the fortunate few who were singled out and given extra tuition stood any chance of gaining a scholarship and the scope to advance their studies.

Today at Harbury School the children are taught not only the basic academic requirements needed to survive in a materialistic world, but are encouraged to extend their knowledge by undertaking many interesting projects, giving them the stimulus they need. Projects such as a survey into the building of the M40 Motorway, not only covering the actual building process which they did by visits to the site and personal interviews with some of the professional staff involved, but

also examining the local advantages and repercussions of such an undertaking.

They are also made aware of the history of Harbury, the buildings and the people, both past and present. The facts that they have amassed with the help of knowledgeable people such as Celia Barratt and her family, whose origins are rooted in the village, will, I hope, be well documented for future generations.

Chapter Eleven

HIGH DAYS AND HOLIDAYS

The special days of my childhood were mostly days marking religious events. In the language of Old English the word 'Holiday' derives from the words Halig – Holy, Doeg – Day. Many of these Feast Days were Pagan in origin and had been gradually adapted to accommodate the later transition towards Christianity.

May Day was celebrated long ago by the Romans and our own ancestors, greeting the spring, heralding the rebirth of all growing things. In more modern times, May 1st was declared a Public Holiday with political associations.

We village children made our own 'May Poles' from a circle of wood attached to the end of a short carrying pole. We bound the whole thing with strips of coloured crepe paper or raffia, then tied small bunches of wild flowers all around the ring. Taking turns to carry this ancient fertility symbol, we went from door to door singing the old May Day songs continuing an age old tradition reaching far beyond recorded history.

Pancake Day on Shrove Tuesday was a favourite 'Special Day' of ours. To the accompaniment of a chorus of oos and ahs our mother would demonstrate her expertise by tossing each pancake high in the air, catching it neatly in the frying pan held below. These were always eaten hot straight from the pan, covered with a liberal sprinkling of sugar and a generous squirt of fresh lemon juice. Shrove Tuesday falls on the day preceding the beginning of Lent and it is generally accepted that the original purpose of this special dish arose from the need to use up any left-over flour before the period of fasting started on the following day, Ash Wednesday. However, my own theory is that it was the last chance for a marathon 'blow out' before the lean days ahead that unfortunately came at the end of a long cold winter!

Pancake races take place in various parts of England. One story tells us that in the 1500s a housewife was in the middle of cooking her pancakes when she heard the sound of the last bell for church. She ran through the streets, late for the service, still carrying her frying pan, and, it is said, that it was from that incident the idea of these races grew.

On Empire Day, May 24th, the village school classrooms were decorated with streamers of red, white and blue and the 'Union Jack' was given pride of place. One year our whole class took part in a tableau depicting

the many countries of the British Empire. Some of us were garbed in the tall, black, frill trimmed hat and tweed shawls that is the traditional costume of Wales. Scottish pipers in their plaid kilts and small figures representing Ireland clad in green and carrying cardboard harps abounded, mingling with the more flamboyantly dressed, portraying the African and Far Eastern colonies were the Australian, New Zealand and Canadian contingents.

With the demise of the old colonial days, exotic names such as The Ivory Coast, The Congo and Ceylon have now disappeared, being changed when each country gained independence. And, as I write, Australia is preparing to become a Republic, cutting her ties with mother England.

On November 5th, Bonfire Night, we always had our own bonfire at the bottom of the garden where my parents would have been collecting inflammable rubbish for weeks. We children would wait impatiently for darkness to fall, allowing the fun to begin and would follow Dad around as he carefully nailed the large fountains, Catherine wheels, rockets and other loud and colourful marvels to delight our eye and deafen our ears, high up onto the side of the woodshed and other prominent places around the garden, where we could observe these wonders in complete safety, though we were always given a few 'sparklers' that we could hold in our hands.

Dad would then disappear inside the 'Hovel' to put the finishing touches to the 'Guy' that he had been (secretly?) making all ready for our mother to dress in an old cast off jacket and trousers of his own that would have been somewhat reluctantly donated for the occasion. The smart outfit was always topped by some kind of headgear, knitted hat or an old tweed cap. When darkness fell, with great ceremony he would carry the guy up the garden path and place him on top of the pile for all to admire. Then, with a flourish, he would set the bonfire alight. How sad it was to see that unique straw filled work of art consumed by the flames. This whole exercise, we all know, depicts the demise of poor old Guy Fawkes, who did his best to blow up the Houses of Parliament with gunpowder in 1605. It seems that even in those far off days the long suffering public could become disillusioned!

Once again food was the order of the day. We finally fell happily into bed, tired out and stuffed full of jacket potatoes that we had eaten oozing with melted butter, washed down with steaming cups of hot cocoa.

Whitsuntide, celebrating the Feast of Pentecost, was another holiday weekend although no special customs or food seemed to be connected with this annual event.

On Good Friday morning, after an early breakfast of Hot Cross Buns, we would set off in droves to walk to the woods at Ufton or Chesterton which were always open to the public on that one day a year when we

would legitimately ignore the 'Trespassers will be Prosecuted' signs. There we picked posies of Primroses and Violets and bunches of Catkins or Pussy Willow. These we presented to our families and friends.

On Easter Sunday the day would begin by 'stocktaking' the number of Easter Eggs that we had received depending on the generosity of grannies and aunts. These were broken up and eked out daily piece by piece. This way they would last several weeks if we had been lucky. Eggs were exchanged by the Ancient Egyptians and the Romans as fertility symbols long before the advent of the numerous and delicious chocolate concoctions that are produced today.

Easter was once a Pagan ceremony dedicated to 'Eostre' the Goddess of Spring.

We were always turned out, smartly dressed in a new outfit at Easter. The girls' pretty cotton dresses were always complemented by a shiny straw hat. One year mine was a pale green creation, trimmed with tiny artificial flowers and a bunch of narrow satin ribbons which hung down the back. But, best of all, the rim was turned back into what was known then as the 'halo' style. I remember feeling like a princess as I sat in church at Sunday School to see that all the other little girls were wearing the conventional 'Panama' hat with the brim turned down! As always, a special dinner was served on Easter Sunday, although not as heavy a meal such as we had on Christmas Day, but roast spring lamb and a fruit tart with 'real' custard made with eggs in the old fashioned way.

On mothering Sunday at the end of the morning church service, children were always given a small bunch of primroses to present to their mothers. Mother's Day has now become a vast commercial enterprise, as has father's Day, which we seem to have inherited from our American cousins and, as far as I am aware, this has no religious connections at all.

Fairs and Mops have been held countrywide for many centuries. Traditionally held each Michaelmas Day, September 29th, originally held as a hiring fair when country men and women seeking employment would arrive early in the morning, the men dressed in their working smocks. These were embroidered across the front of the shoulders in differing patterns according to their particular skills. Some would also carry the tools of their trade, for instance a shepherd would carry his crook. It is thought that the art of fancy smocking sprang from these humble beginnings. When a fair wage had been negotiated, a coin would be exchanged between the farmer and his new employee sealing the contract for a term of one year.

Our visit to Southam Mop was eagerly anticipated. We gazed in awe at the huge ox roasting on the spit, turning round and round, giving off a mouthwatering aroma. How wonderful it felt to be riding on the swingboats as we flew higher and higher in the air, pulling harder and harder on

the thick red velvet ropes, or walking on the rickety cakewalk. We tried our luck on the roll-a-penny stall and attempted to throw a wooden hoop over a coveted prize on the hoop-la stall. Then there was the exciting ride on the roundabout, riding up and down to the music on the brightly painted animal of our choice. As we looked on admiringly Dad would have a go on the coconut shies, always managing to dislodge one of those rare fruits which was carried home in triumph along with the sticks of Mop rock and other booty, as we sleepily walked, late into the night, back along the old Welsh Drovers Road towards home and a warm bed.

A visit to Banbury Market was always a welcome treat, usually taking place after the Co-Op 'divi' had been paid out. In those days with each payment of cash a small receipt was given bearing the member's own number. I still remember our number – 602. At the end of the financial year the Co-Operative Society paid out to each member a small amount of dividend according to the total sum of cash spent. In those days we walked down to Harbury Station to catch the train.

Later Dad became a member of the Cement Works Bowling Club and we often accompanied him when they were playing a match at Banbury. During the game we were free to explore the town with our mother. Banbury Cross, which stands in the centre of the old Market Place, was built in 1859 to replace the Medieval one destroyed in 1602 by the Puritans. Banbury dates back to Saxon times and was famous for the woollen cloth made there in the thirteenth century. The 'Fine Lady' of the well loved nursery rhyme, sung to children for decades, may have been Queen Elizabeth Ist or Lady Godiva of Coventry, but is more likely to have been based on the May Day custom when a local girl rode a horse at the head of the procession. Jonathan Swift, the author of 'Gulliver's Travels' which he wrote in 1726, took the name for the hero of this book from a tombstone in Banbury churchyard, where it can still be seen. At the end of the day out, the long walk home from Harbury Station seemed unending, a challenge for our small tired legs. However, the thought of the delicious Banbury Cakes purchased for tea by our mother was an incentive to hurry home as fast as we could. I wonder if 'Ye Olde Banbury Cake Shoppe' is still there?

Without a doubt Christmas was the most exciting time of the year with celebrations going on from Christmas Eve through the Boxing Day. On Christmas Eve we always hung one of my father's socks from the mantelpiece. Without fail each year the contents next morning would be – a sixpenny piece wrapped in silver paper, one tangerine, one apple, a small net bag full of chocolate coins and a cone-shaped bag of sweets. Poking out of the top would be a small toy, perhaps a small celluloid doll or a story book for me and a tin whistle or a miniature train for my brother. I remember

one year I received a cut out book that featured cardboard figures of the Princesses Elizabeth and Margaret Rose that stood up and a whole wardrobe of clothes to dress them for formal and informal occasions. I was delighted and spent many happy hours playing with this welcome gift.

After leaving a small glass of wine and a mince pie in a prominent place for father Christmas to find, we would reluctantly retire to bed, finally dropping off to sleep with the agonising thought that he may not be able to negotiate our chimney or, by some awful oversight, he may miss our house altogether. Dad would by this time have gone off to the Clubroom or the Dog Inn for his usual pint (or two) leaving Mum free to trim the Christmas tree, which she always did after we had gone to bed. She would then prepare the stuffing for the chicken and carry out the hundred and one jobs that must be done in advance to produce a full blown, good old-fashioned Christmas dinner the next day.

It was with a sense of relief that we found on waking the next morning the pile of neatly stacked presents at the bottom of the bed. One 'big' present from our parents and lots of others from close members of the family. David and I also received a Rupert Annual which we shared. Our Granny Mann and our father's sisters, Ethel and Gladys, were all keen needlewomen and often we were the recipients of warm scarves, hats, jumpers and cardigans, hand-made with love and affection woven into every stitch.

Hidden under our beds, carefully wrapped, would be our own contributions. A hand-made spill box and covered matchbox for Dad, a raffia mat to be used as a teapot stand and an iron or kettle holder for Mum; or perhaps a pin cushion stuffed with lambswool found caught on a fence during one of our long walks, the natural oil in the wool to keep the old fashioned pins from rusting. These we would have laboriously toiled over in our handiwork lessons at school. Similar gifts would later in the day be handed out to astounded grandparents, congratulating us on our neat work and assuring us that "it was just what they wanted"!

As we became older and a little more affluent, my father would receive an ounce of 'St Julien' tobacco and my mother a small bottle of 'Evening in Paris' perfume contained in a distinctive dark blue bottle. Other perfumes of the day I remember were 'Californian Poppy' and 'Phul Nana'. These we purchased from Woolworths. If we had enough money left over we would often add a lurid bottle of bath salts or a tablet of Knights Castile soap. This soap was advertised in the magazines in a strip cartoon featuring a glamorous creature by the name of Norma whose adventures I followed with great interest.

After we had raced downstairs for a first glimpse of the glittering Christmas tree, we checked that father Christmas had indeed partaken of the

light refreshment. Not for one moment did we really suppose that he could possibly have overlooked it, for didn't we leave the sherry and mince pie in the same place each year? We were now free to sit down and eat our Christmas morning breakfast. Pork pie and bread and butter and everyone, even we children, received a teaspoon full of whisky in our first cup of tea.

Christmas dinner was served about two o'clock and the menu was always the same – roast chicken stuffed with sausage meat and thyme and parsley stuffing, roast potatoes, braised parsnips, Brussels sprouts, gravy and bread sauce. The pudding, mixed in the large china bowl that was once part of an elegant bedroom set that had long since been parted from the matching jug and soap dish, had been made in October when we had all had a stir and made a wish. This would be lifted out of the pan of boiling water where it had been simmering for several hours contained in a white earthenware basin covered with a piece of linen sheet tied over the top with string. Just before serving the rich spicy pudding my mother would drench it all over with a glass of brandy then set it alight. We were fascinated by the flickering blue flames. This was served with custard or home-made brandy butter. We all hoped that we would find one of the silver threepenny pieces that were hidden inside the pudding. There would also be a plate of hot mince pies on the table and to finish off, home-made sweets were handed round. After this enormous meal most of the adults fell asleep leaving us to enjoy playing with our new toys.

The huge home-made Christmas cake that our mother had so carefully covered with marzipan and icing would sit in the pantry, topped by the same perky looking robin on a log that came out each year. There he would sit waiting for teatime and the first thrust of the sharp knife that would intrude upon his snowy domain.

The evening was always spent at my Aunt Enid Bayliss' cottage in Dove House Lane, where the whole of the Harbury Mann clan would gather. Thinking now of the size of this small house, I wonder how we all managed to fit into that tiny sitting room but, somehow, we did. The men of the family and some of the ladies played cards. Aunt Enid (who was my Godmother, and I would like to record that I remember her with great affection) was an avid whist player and like so many devotees took the whole thing very seriously. Heaven help any player who chanced to put down the wrong card whilst partnering one of these fanatics! At the end of the day we were pleased to fall into bed. Like children through each generation we had been up since about 5.30 am when we woke to investigate our presents.

Our Granny and Grandfather Taylor, our young Uncle Frank, who was only five years older than me, and my mother's sister, Aunt Olive, my other Godmother whom I think of with equal affection, always spent Boxing Day

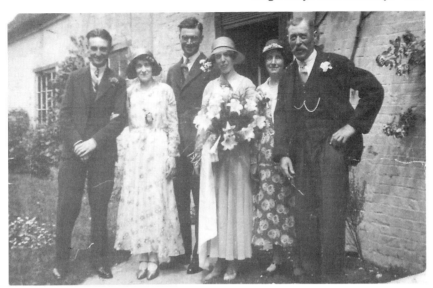

A Mann family wedding group taken outside Church House, Pump Street.
Bride and Groom, Enid Mann and husband Frank Bayliss.
Granny and Grandfather Edmund Mann on right.
Evelyn Mann and husband Harold Fox on left.

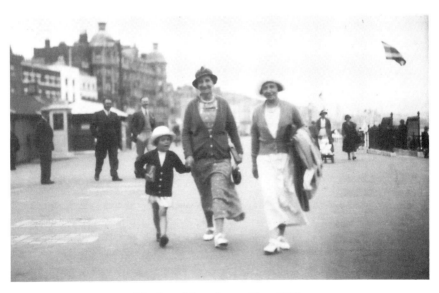

My first visit to the seaside – 1935 –
with Granny Mann centre and Aunt Amy.

with us when there was more excitement in the giving and receiving of gifts. In those days there was none of the build-up to Christmas-time which marks today's festivities. Christmas for me is a family time. Now, each year surrounded by the ever increasing younger members of our tribe, I reflect on those wonderful times of Christmases past and remember with gratitude the love and kindness shown to us by those who are no longer here.

Trips to the seaside were a rare event, although I had my first glimpse of the sea at four years old when Granny Mann took me to Weymouth for a week. The experience was not to be repeated until our whole family visited Rhyl in North Wales towards the end of the war. Because of rationing we took all our food with us, including huge bags of fresh vegetables and an enormous joint of our own home cured ham. Mrs Jones, our landlady, was I remember an excellent cook. One of her specialities being mouth-watering apple dumplings which we children requested every day.

We spent two wonderful weeks exploring the beautiful Welsh landscape so different to our own flatter native Warwickshire. I still remember the thrill when, on reaching the top of a mountain after a long, hard climb, seeing the magnificent view and the feeling that I was standing on top of the world. As the weather was warm and sunny we were able to paddle in the sea despite the barricades stretching far into the water. These were placed all around our coastline, sea defences in preparation against the possible invasion by the enemy. Each day we took a picnic lunch and explored Rhyl and the surrounding area. I remember in particular the marble church at Bodelwyddan and Conway Castle where Dad explained what the original building must have once looked like and how the whole community would have lived inside the castle walls. It seems incredible now to think that it was the first castle that I had seen and we live so close to Warwick!

At the age of sixteen I was allowed to go with a group of friends to Blackpool for a week. It cost the princely sum of four pounds ten shillings for board and lodging and seven pounds pocket money at the rate of one pound a day. We had a marvellous time. Dancing and singing along to Reginald Dixon as he played the mighty Wurlitzer organ in the Tower Ballroom, also dancing to Ted Heath and his orchestra in the Winter Gardens Ballroom. Jack Parnell, who has carried on the family tradition and is today a famous theatrical entrepreneur, was then the young drummer in Ted Heath's band and just as the youngsters behave today at the sight of their current pop idol, we all screamed and almost swooned with joy each time he appeared.

Among the famous stars of the day we saw at the various theatres in Blackpool were Gracie Fields, who sang the song that she made famous

during the war 'Wish Me Luck' and the American Sophie Tucker, who was always billed as 'Last of the Red Hot Mammas'. Her emotional rendering of 'My Yiddisha Momma' and 'Some Of These Days' almost brought the house down. Others we saw included Teddy Brown whose girth was almost as wide as the xylophone that he played so brilliantly, Albert Modley, the North Country comic who had everyone in stitches with his huge tweed cap and his gormless, dry sense of humour. G. H. Elliott, billed as 'The Chocolate Coloured Coon' singing his famous song 'I Used to Sigh for the Silv'ry Moon', Rawicz and Landauer, those brilliant pianists whose fingers seemed to fly over the keyboard, and Tessie O'Shea, a large lady with a voice to match, playing the banjo.

The only blight to our first adventure away from home was the loss of one girl's wallet. We arrived back in Harbury at the end of a fabulous week, all agreeing that it was eleven pounds, ten shillings well spent!

In those days there was no public transport available. However, we in Harbury and the surrounding villages were fortunate to have the services of Jimmy Edwards who owned his own private coaches. He was a jolly, obliging, patient man and although there were proper pick-up points along the way, he always seemed quite happy to collect and drop off anyone anywhere en route. He operated his business from his premises in Gaydon Road at Bishops Itchington. Starting off in a small way in 1922 he purchased his first vehicle, a Ford 'T' Motor Van and became the village carrier eventually employing three other full time drivers and owning five buses.

As well as shopping expeditions into Leamington each week, I remember during the summer he ran what were known as 'Mystery Trips' on Sunday evenings. We always went on these expeditions with my maternal grandparents. When the coach drew into the Bullring at Harbury my grandmother, having boarded the vehicle at Cross Green, Bishops Itchington, the starting point, would be seated directly behind the driver and would have commandeered the rest of the front seats for us by covering them with a collection of handbag, umbrella, coats and cardigan. Granny Taylor, a formidable lady, was never the ultimate of tact. In fact she was outspoken to the point of rudeness. No-one who knew her would dare question her actions and so risk a lashing from that sharp tongue. I would cringe with embarrassment when during the journey she would make comments such as "I hope we are not going to Compton Verney *again*. We went there twice last year" or "Oh! not Stratford-on-Avon I hope". All this in a piercing voice only inches away from the driver. I imagine that he probably changed his route several times during the evening, turning the whole thing into somewhat of a Mystery Tour for himself.

Another day out was the annual Chapel outing when we always went by

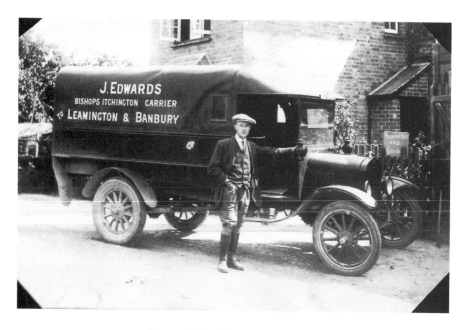

Jimmy Edwards' first motor vehicle

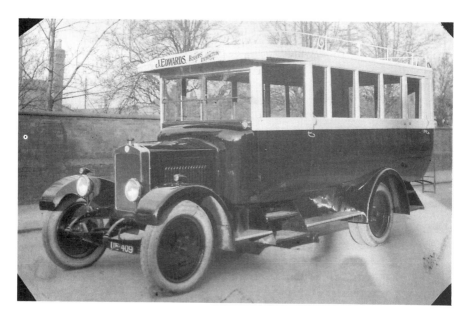

Jimmy Edwards' first bus

coach to Wicksteed Park. The big event of the day was a ride all around the grounds on the scenic railway in small open carriages. One year I remember a sudden gust of wind carried off my mother's hat. "I'm glad that's happened," she said, "I never liked that hat". Imagine her disgust when we we arrived back at the terminus to find a small boy panting and red in the face from the exertion of the chase, holding the wretched head-gear carefully in his hands. To add insult to injury, she then felt honour bound to reluctantly hand him a sixpenny piece for his effort!

Our mother also attended the monthly meeting held at the Chapel of the 'Ladies' Temperance Society'. On these afternoons David and I would race out from school making our way round to Chapel Street, and on the pretence of meeting our mother, would be let in at the side door. We knew that Mrs Calloway, who was Granny Mann's neighbour, would, if we sat quietly, eventually offer us a cake and a drink. Now we had been schooled well in table manners by our mother and when offered the plate were taught always to take the cake nearest to us. I always said a silent, fervent prayer "Dear God, don't let it be the carraway seed cake". It nearly always was!

By the time the war ended, we had reached the age when those old films shown by the travelling cinema man had become distinctly 'old hat' although some of those films are now classics. I am thinking particularly of films such as 'Sanders of the River' starring that wonderful singer Paul Robeson and stars such as Will Hay, Moore Marriott and Graham Moffatt, that loony trio causing havoc as they blundered their inept way through the most ridiculous situations in films like 'The Ghost Train' and 'Where's that Fire' when they ran the fire station at Middle Wallop with Will Hay as Chief Fire Officer, and who could ever forget the disastrous results when, through a mix up at the interview, Will Hay was appointed as the Governor of the prison in 'Convict 99'.

My first visit to the 'real' cinema was when I was taken to see Snow White and the Seven Dwarfs. I didn't enjoy the experience at all and spent most of the time with my hands over my eyes crouched down in front of the seat in front of me, terrified each time the wicked queen appeared on the screen. In fact, as I recall, I wasn't terribly keen on the dwarfs either.

For a twelfth birthday treat my Aunt Ethel took me to the Regal Cinema in Leamington to see Vivienne Leigh and Clark Gable in 'Gone With The Wind' followed by a cream tea at the Café Collette in Bath Street. This experience was far more satisfactory. The 'Picturegoer' had now replaced the 'Dandy' and the 'Beano' as our reading matter. We also cut out pictures of our favourite stars from the 'Picture Post' and the 'Illustrated' to stick in our treasured scrap books. Among them were Alan Ladd, Stewart Granger and Betty Grable of the famous legs. I remember we were fasci-

*Annual outing from the Dog Inn leaving Harbury Station
complete with crates of beer (liquid refreshment!)*

Christmas Party in the old Women's Institute Hut – 1940s

nated by Veronica Lake who always wore her hair draped over one eye. This gave us much cause for concern. Had she been in an accident, we wondered, that had left her terribly disfigured or, turning to the more dramatic, had she been born with only one eye? I remember twisting my neck around to see if I could detect any sign of facial scarring each time we saw her films.

The first thing that we did on entering the cinema was to go along to the ladies' cloakroom (thick carpet and gilt mirrors everywhere) and make up our faces with our Woolworth's face powder and lipstick. This we wore only in the cinema where it was dark, paying another visit to the cloakroom at the end of the programme to remove all traces of the prohibited product just in case we ran into anyone who knew our parents. The seats in the cinema cost ninepence for the front seats, one shilling and ninepence further back where the floor sloped giving a better view, and two shillings and threepence up in the balcony. We went in the ninepennys and would try to move further back when the usherette wasn't looking. We were nearly always caught!

If we had enough money we would treat ourselves to afternoon tea at the Polka Dot Café in Warwick Street. The full menu cost two shilling and sixpence each and included bread and butter and jam, scotch pancakes and a cake, plus a pot of tea for two. We felt grown up and full of importance as we perused the menu, longing for the day when we were affluent enough to add to our order poached eggs or beans on toast.

Today, when watching one of those old films that are now shown on late night TV, I am immediately transported back to those halcyon days when my friends and I sat in the front row of the ninepennys. Completely oblivious of our surroundings, when for a short time we entered the world of make believe and stood by the side of those old time stars sharing the glamour and excitement and I swear that strawberries and cream at Wimbledon or afternoon tea at The Ritz never tasted half as good as that halfcrown 'special' at the Polka Dot Café.

Chapter Twelve
A CHANGING WORLD

When the war ended in 1945 the winds of change began to blow. Women were reluctant to relinquish the freedom and camaraderie that work outside the home had provided. No longer were they content to drift back into the old way of life merely as wives and mothers as decreed for generations. Through necessity they had learned how to cope with a job, a home and a family. They had tasted freedom. Freedom to become independent individuals with a range of outside interests and a broad choice of employment far removed from domestic service and shop work and perhaps, most important of all, the independence of their own wage packet. Some children would never now know the joy of arriving home from school on a cold winter's day to find a pile of hot pancakes or dropped scones waiting for their tea. The phrase 'Latchkey Kids' was born.

Vaguely familiar faces began to appear around the village. Faces half forgotten by the younger element. Little wonder when remembering that some of these returning servicemen had been away from their families for several years, serving overseas.

The German and Italian POWs were repatriated and replaced by men that were officially described as 'Displaced Persons'. These were mostly of Slavic origin and were accommodated in the nissen huts that had until then housed our own and our allied armed forces.

This was an exciting time for my contemporaries and myself teetering on the edge of our teens. Feeling that first flush of independence that seemed to make parents, especially of daughters, more alert and protective. In turn this is interpreted by their offspring as suppression and a lack of understanding by these 'old fogies'. Unfortunately we never understand the motives behind this more vigilant attitude until we ourselves become parents.

At this time several social groups were formed in the village. Mr Tudor, the farmer from Chesterton House Farm, Ralph Gurden from Hillside Farm and Roy Turner, who was then the proprietor of a garage and motor and farm implement repair business in the Bull Ring, were amongst those people who began a Young Farmers Club held each week in the Women's Institute Hut. A crowd of us would make sure that we arrived at the venue in plenty of time to hold a private dancing session before the meeting began. Joyce Hewitt, one of our group, was an able pianist. There we would

show off our expertise in dancing the slow foxtrot, the quickstep and the jive. How those old floorboards would bounce as we demonstrated our prowess to the accompaniment of the 'big band' favourites of the day such as Glen Miller's 'In The Mood', 'Jersey Bounce' and 'Little Brown Jug'.

One of the most supportive farmers from outside the village was Mr Edgar whose young son and daughter were even then accomplished horse riders and went on to become well known champions in the world of show jumping.

We had great fun visiting other clubs, transport by courtesy of Roy Turner, who then owned a large ex-Army covered lorry into which we would all pile.

All this despite minor hiccoughs such as the time that we were reported by an over zealous WI Committee member for not leaving the kitchen as tidy as was expected. This resulted in the matter being raised at the following monthly meeting. Now most of our mothers were staunch WI members and were, of course, present when the President, an elderly dame from the village hierarchy, was unwise enough to pose the following question, quote: "Ladies, do we really want these young clodhoppers using our premises?". I gather that there was a moment of deathly silence, followed by the hiss of a collective drawing in of breath, a sound that would have done justice to a nest of vipers. Then the uproar began. One irate mama leaping to her feet and red in the face shouting "Don't you dare call my . . . a clodhopper". Completely outnumbered, Madam President was forced to retract the statement, apologising profusely. The matter had been settled in the usual village manner!

Several of us joined the Girls Training Corps, cycling to Bishops Itchington accompanied by our Senior Officer, Mrs Bicknell, a village schoolteacher who taught at Bishops Itchington School and lived in Harbury. We met in the Memorial Hall which had been built after World War One in memory of those men who lost their lives. There we learned the basics of first aid, went away to summer camp and, amongst many other activities, once produced a very amateur Christmas pantomime, our version of Snow White and the Seven Dwarfs! A few of us took tap dancing lessons and I can say in all honesty that the careers of Ginger Rogers and Fred Astair were never even remotely threatened.

One of the highlights during this time was when we all attended a mass rally in Hyde Park. Princess Elizabeth took the salute as we marched past with mixed emotions, each one of us feeling a sense of elation and importance wearing our smart navy blue uniform. The Princess was again present that same evening when units from all over the UK presented an extremely professional performance in the Albert Hall.

During what was for most of our group our first visit to the capital city,

our allocated accommodation lay deep down in the underground shelters that had been used during the wartime air raids. I remember thinking how well designed and comfortable they seemed containing row upon row of bunk beds and adequate provision for our ablutions. A thrilling adventure for us. An exercise in fun. We had never been in physical danger during the war years. How different it must have been for those original occupants.

In 1947 a new vicar arrived, complete with a very glamorous wife and a young family. The Reverend D. A. G. Atcheson (whom we promptly nicknamed Dagwood after the popular strip cartoon character) had served in the Paratroop Regiment and his young wife was a trained actress and singer. They swept into the village like a breath of fresh air. We young people were immediately caught up in the scheme of things. A Youth Fellowship group was formed and a large room, one of the many contained in the old vicarage, was given over for us to use any evening. It was wonderful, we now had our very own place where we could meet to drink coffee, play our music or just chat.

Attending church was no longer a chore. Much to our amazement we began to enjoy the services. We entertained visitors from overseas, from other cultures and religious denominations which helped us to understand their beliefs and customs. After church each Sunday evening we took it in turns to go back to each other's homes for discussion and refreshments.

Mrs Atcheson helped us to produce concerts and plays which we presented in the Wight School. The dividing screen was removed and staging erected which we borrowed from the Cement Works and the small classroom at the far end became our dressing room. Everyone worked hard with great enthusiasm. The village supported our efforts wholeheartedly with the loan of props and costumes, help with providing and painting scenery and the hundred and one things that go towards making such a production a success. Mrs Atcheson was our star singer and Cecil Bloxham and Stan Smith our standup comedians. The rest of us were content to play in the more dramatic roles or we became dressers, make-up artists, programme sellers, etc.

We also organised jumble sales and beetle drives. All takings were donated to the bottomless pit known as the 'Church Repair Fund'. In spite of food rationing which was to go on until the early 1950s, the girls always managed to provide tasty refreshments on these occasions.

However, not everyone approved of the sometimes unorthodox behaviour of our young Reverend. I well remember a great hue and cry from the more staid members of the congregation when he decided to keep turkeys in the churchyard!

The dance hall that stood in Ivy Lane was refurbished by the owner, Mr Pouleve, who also owned the Top Shop, on his release from the forces.

There was absolutely no comparison between it and the WI Hut that up to then had served the village so well. There were separate mirror-lined cloakrooms for Ladies and one for Gentlemen, set on either side of the main entrance hall. Elegant glass double swing doors opened directly onto the beautifully sprung dance floor. At the far end, on one side was a small raised area for the band and on the other side a buffet bar where refreshments were served during the interval, tea and coffee only – no alcohol.

One of our favourite bands was the 'Zither Band' from Southam. Who could ever forget their rendition of 'Twelfth Street Rag' and 'The Dark Town Strutters Ball'. Miss Bustin, a member of the old Harbury family who opened the first Harbury Co-Operative Store in the mid eighteen hundreds, and a very strict retired teacher, held 'Old Tyme' dances. The MC was Mr Harris from Farm Street and the music was supplied by George Bishop on the drums and Miriam Alcock on the piano. We were not allowed to deviate from the original steps and if we dared to swing our legs out too far during the Military Twostep she would clap her hands and shout "Stop the music Mr Harris" and threaten to evict the culprits. I must admit that, like all young people, we did enjoy playing her along.

For a time, after the arrival of television, the art of conversation almost died, at any rate, it certainly lay dormant for quite a while! The few people that first acquired a set very quickly found that they had a much larger circle of relatives, friends and close neighbours than they had realised. Saturday and Sunday evenings had always been the time for paying social calls. Often whole families would arrive en masse. The women would sit by the fire and chat, catching up on local gossip. The children would play a quiet game of Ludo or Snakes and Ladders while the men would sample a glass of home-made wine and perhaps play a game of cards or dominoes.

It soon became evident that it was regarded as anti-social to call on anyone with a TV set at prime viewing time. If by any chance you did so, on entering the house you would find everywhere plunged into total darkness. All eyes would be turned towards the ethereal glow of the TV set, the altar around which would be grouped the dedicated worshippers. A deathly hush would prevail and should you dare to venture a timid 'good evening' in greeting the ensuing chorus of tutting and groans would make you wish that you had stayed at home by your own warm fireside listening to your own old fashioned wireless. At the end of the programme there would be a mass exodus with scarcely a goodbye as those who had a set in their own homes scurried away in time to catch the epilogue and the national anthem.

The screens on these first sets were very small. They appeared to be twelve inches square, however, it was possible to fit a second screen in front which magnified the picture. Unfortunately, this meant that only

The Six Wives of Calais – play in W. I. Hut
Left to right: Mrs Hounsell, Frances Mann, Mrs Bird, Mrs Keeling, Gillian Mann,
Mrs Spike – sitting, Mrs Savage

The Hereburgh Dancers – 1994

those sitting directly in front of the TV could see a proper image. If you happened to call on an evening when there was a 'full house' and were given a 'side seat' all you could see was a distorted view, a little like those seen in the trick mirrors at the House of Fun in Blackpool Tower. In those early days of TV there was only one station. This was transmitted by the BBC and, of course, in black and white. The wedding of Princess Elizabeth and Prince Philip was televised, as was the Coronation in 1953, much to the delight of the TV retailers.

For a number of years the national Hedge Cutting Competition was held at Harbury and a well known Harbury resident, Bill Neale, held the title of champion for several seasons. During these events Harbury was a hive of activity. Many came to view the intricate work involved and that ancient art of hedge laying that was once a part of the seasonal cycle of hedging and ditching. Now an art that has almost become obsolete.

The State Education System was completely reviewed. In 1946 the school leaving age was raised to fifteen and a little after this the 'Eleven Plus' examination came into being, giving for the first time an equal chance for every child to go on to further education, even to university, until then a privilege afforded only to a chosen few. No longer would academically bright children languish in village schools, bored stiff having completed the available curriculum but would now, at the age of eleven, move to grammar school or one of the newly built high schools.

The Welfare State was born conceived from an idea by Aneurin Bevan, promising an ideal world for all where everyone would be cared for from, quote: 'The cradle to the Grave.' In a comparatively short span of time we have progressed from the small village surgery tacked onto the end of the doctor's house where he diagnosed, and administered treatment, mixing his own magic potions for the relief of the many and varied onslaughts that occur to different areas of our anatomy. Health centres, manned by an efficient army of medical and ancillary staff have now replaced those hard working and dedicated professionals, not forgetting the equally dedicated district nurses who usually had only one means of transport, a bicycle.

These and other social changes were to have a far reaching effect. Not only the way of life that my generation had known, experiencing a brief glimpse of village life as it had been played out for many generations, but on life in general.

Many changes have taken place in and around Harbury since those far off days when my family and I lived in that small cottage in Church Street. There are the obvious physical changes caused by the expansion of the village, pushing outwards in an ever widening circle. Sadly, many of the old names, those that are woven into the very fabric of the village, are no longer in evidence. Younger members of these families have moved away

finding it impossible to compete with the inflated price of property since the adjacent motorway attracting commuters came into being, attracting a more affluent type of resident. This, in turn, encouraging developers to build larger, more expensive homes to meet their requirements.

As a child I can remember lying in bed trying to induce sleep by closing my eyes and making a mental journey from one end of the village to the other. Travelling every street and lane cataloguing each house and cottage, counting the number of occupants. Today this would be an impossible exercise. Then everyone knew everyone. In fact, quite a few of us were related in some way or another, even if only as a distant cousin. Not surprising when, out of necessity, 'courting' took place on a far more parochial basis. After all the only means of travel for the majority was by foot!

In that small, closely knit community neighbours would rally around when one of our mothers was sick or in bed with a new baby during the then accepted 'lying in' period after childbirth. One kindly soul would pop in and out of the house to make sure that the other children were clean and tidy, ready for school and sufficiently fed. Another would produce a cooked evening meal for the man of the house, usually served between two deep enamel plates and placed inside the coal oven to keep hot. Dirty clothing and bed linen would be taken away to be returned the following day washed, clean and neatly ironed. In turn everyone helped each other in times of need.

Since the end of the war, a huge range of Social Services have been implemented and, as foretold by Mr Bevan, cover all eventualities from birth to old age. Although most of these have been necessary due to vast changes that have occurred within modern society, not least the disintegration of the extended family, I often feel that this has resulted in a lack of day-to-day communication between ordinary folk.

The Cement Works at Bishops Itchington has disappeared and I believe there is a plan to utilise the land to provide more of those exclusive type dwellings. The tall smoking chimneys and the chain of buckets that once rotated in a never ending circle emptying their contents upon the ever rising mountains of slag no longer dominate the skyline. The quarries where men once toiled with shovel and pick leaving gaping holes have now been transformed into wonderful nature reserves. The deep pits of dark water have been stocked with fish and have become a haven for many of our rare aquatic birds and animals. Wild flowers, those that only thrive in chalky soil, butterflies and birds, many that had been almost lost due to the disappearance of their habitat, thrive once again. This has also taken place on the site of the old quarries at Ufton. How good it is to see this thoughtful kind of restoration taking place.

The ancient Plesiosaurus and Ichthyosaurus that were so rudely taken

from their rocky graves of many millions of years can now rest in peace in the British Museum where they repose for all to see, safe in the knowledge that the land where they once roamed freely is peaceful again.

Gone are almost all the native elms due to Dutch Elm Disease, along with the marching rows of thick wooden telegraph poles that carried the telephone wires, now neatly tucked away below ground. A favourite gathering place for hundreds of swallows preparing to migrate at the end of the English summer to warmer climes.

Where, during my childhood, there were small fields planted with a variety of crops, there are now acres of yellow rape and blue borage stretching as far as the eye can see. Many of the old hedges have been removed, destroying the homes of many small mammals and birds, to create larger areas to enable one man and one machine to do the work more quickly and efficiently than in days of old, when many men and their patient oxen, followed by the lumbering cart horse, first cleared then cultivated our land. Now these mammoth machines sow and harvest the seed, spewing out neatly wrapped identical plastic parcels at precise intervals.

The village streets, once so quiet, are now abuzz with traffic during the day and packed with vehicles parked end to end at night, parked outside the modernised cottages that were built when such transport would have seemed as impossible as my contemporaries when young would have considered a landing on the moon!

Harbury now contains a blend of the old and the new, that for the most part sit comfortably side by side. There are the 'old' residents, those whose names are etched in Harbury's history, and then there are the 'new' residents, those that have only resided in the village for say twenty years or less (I say this with tongue in cheek). These 'newcomers' have contributed many fresh ideas. For example, I am thinking of the colourful 'Hereburgh Morris Dancers' and the 'Harbury Society' whose aim is to prevent further destruction of local historical sites and buildings.

Today so much is going on, something to suit most tastes and age groups. The annual Carnival continues to be held during the summer, complete with Carnival Queen, and the exciting 'Victorian Street Fayre' takes place later in the year organised by the residents of Chapel Street. Most days the 'Tom Hauley Room' is occupied. This is a fairly recent addition to the church building and dedicated to the memory of a devout Harbury churchman, who, along with many other duties, wound the church clock daily for many years. The Village Hall too is put to good use.

Sadly, many small villages have become anonymous backwaters, so losing their charm and character. Harbury is not one of these. The spirit of Hereburgh lives on – long may she prosper.

The human mind is a little like a video recorder permitting us to replay

our fondest memories at any time. A habit that becomes more prevalent with increasing age.

In conclusion, I would like to say that it would have been impossible for me to have completed this book without the enthusiasm generated by everyone I met during my recent sojourn home, enabling me to look over my shoulder and take a nostalgic walk down the lanes of my childhood.

Family wedding group outside Women's Institute Hut – 1954
Left to right: David, Myself, Father, Mother, Sister Gillian

The Be-ro Logo

CUT AND COME AGAIN CAKE

Ingredients: 8 oz. S.R. Flour
4 oz. Sugar
4 oz. Margarine
1 tsp. Mixed Spice
6 oz. Mixed dried fruit and peel
2 Eggs beaten with 3 tablespoons milk
1 tbsp. Golden Syrup

Method:

Mix together flour, spice and fruit. Beat sugar and margarine to cream then stir in the beaten eggs, milk and syrup alternately with flour mixture, a little at a time. When thoroughly mixed, bake in well greased 8" tin at moderate heat for about 1¼ hours.

BASIC SANDWICH CAKE

Ingredients: Weight of 3 eggs in sugar, margarine and
S.R. Flour.
If chocolate cake desired, add 1 tbsp. cocoa.

Method:

Beat eggs together with a little milk. Cream sugar and margarine, add flour and egg mixture alternately a little at a time. Cook in two well greased sand-wich tins for about 45 minutes in moderate oven. When cool, these cakes may be sandwiched together with jam or buttercream or iced and decorated.

GILL'S RUSSIAN BREAD

Ingredients: 4 oz. Margarine
1 tbsp. Golden Syrup
4 oz. Brown Sugar
10 oz. Sultanas
8 oz. S.R. Flour
1 Beaten Egg
1 tsp. Vanilla Essence

Method:

Melt the margarine, syrup and brown sugar, add sultanas, flour, egg and
vanilla essence mix well. Cook in flat, well greased tin at 375°F. Sprinkle
top with a good coating of sugar. When cold, cut into squares.

SHORTBREAD

Ingredients: 8 oz. S.R. Flour
 3 oz. Caster Sugar
 4 oz. Butter
 ½ Beaten Egg (approx.)

Method:

Warm butter in bowl, mix in beaten egg, then flour and sugar. KNEAD
WELL. Roll out to 1 inch thickness. Cut into rounds. Prick well. Bake in
slow oven 325°F for about 20 minutes.

DROPPED SCONES

Ingredients: 4 oz. S.R. Flour
 ½ oz. Margarine
 ¼ tsp. Salt
 1 Egg beaten with 3 tbsp. milk
 2 oz. Sugar

Method:

Mix flour and salt in a basin, rub in margarine. Mix in sugar, add egg and
milk mixture gradually, making a smooth batter. Drop teaspoons full of the
mixture onto a well greased, heavy bottomed pan on top of the stove. When
cooked and browned underneath, turn and cook the other side. Eat buttered.

BACON JACK

Ingredients: 10 oz. S.R. Flour
 ¼ tsp. salt
 5 oz. Shredded Suet

Cold water and flour for dusting
Bacon
Onion
Parsley

Method:

Sift flour and salt together. Add suet and just enough cold water to make a dough (not sticky). Roll out into oblong shape, cover with chopped bacon, onion and fresh parsley. Dampen edges of dough. Roll up and seal ends. Cook in well scalded and floured pudding cloth. Secure with string as in a parcel. Simmer in saucepan for about 2½ hours. Serve with savoury white sauce.

Variations on the above recipe:

Roly Poly Pudding
Substitute savoury filling with jam, thinly sliced apple or any soft fruit. Serve with custard.

Spotted Dick
Spread a good handful of dried, mixed fruit and peel over dough then roll up. Delicious served with butter and sugar.

HOME-MADE SWEETS FOR THE CHRISTMAS DINNER TABLE

COCONUT ICE

Ingredients: 2 cups Granulated Sugar
1 cup Coconut
Pinch of Cream of Tartar
½ cup Water or Milk
Cochineal

Method:

Boil all together for 5–10 minutes, constantly stirring. Halve mixture. Colour one half with a few drops of cochineal. Then place one half on top of the other in a wet dish. Press down – when cool cut into squares.

WALNUT TOFFEE

Ingredients: 1 lb. Soft Brown Sugar
12 oz. Butter
8 oz. Walnuts
1 tsp. Malt Vinegar
2/3 cup Water or Milk

Method:

Bring all ingredients, except walnuts, slowly to the boil in a *large* saucepan, stirring constantly. Boil rapidly for about ten minutes, add chopped walnuts. Pour into a shallow, oiled tin. (To test if cooked, drop a little into cold water – it should set straight away). When set break into pieces.

MARZIPAN DELIGHT'S

Remove stones from a number of large, fresh dates. Replace stone with a whole brazil nut. Dredge with a little icing sugar. Roll out ready made marzipan. Cut into rounds with a small fluted cutter. Place a date in the centre of each circle then toll up into a cone shape.

PAT'S NUTTY NO BAKE CRISP

Ingredients: 2 oz. Butter
½ cup Golden Syrup
¾ cup Salted Peanuts
¾ cup Coconut
4½ cups Rice Crispies
1 cup Icing Sugar

Method:

Melt butter, syrup and icing sugar. Stir well until mixed. Cook, stirring constantly, for 2–3 minutes. Add Rice Crispies, peanuts and coconut, mix well with a large fork. Pack firmly in shallow, well greased dish. Put in 'fridge until set, then cut into slices.